A History of
Westbury
Long Island

A History of
Westbury
Long Island

Richard Panchyk

Published by The History Press
Charleston, SC 29403
www.historypress.net

Copyright © 2007 by Richard Panchyk
All rights reserved

Cover Image: Barley's Pharmacy on Post Avenue, early 1900s.

First published 2007

Manufactured in the United Kingdom

ISBN 978.1.59629.213.0

Library of Congress Cataloging-in-Publication Data

Panchyk, Richard.
 A history of Westbury, Long Island / Richard Panchyk.
 p. cm.
 Includes bibliographical references.
 ISBN 978-1-59629-213-0 (alk. paper)
 1. Westbury (Nassau County, N.Y.)--History. 2. Westbury (Nassau County,
N.Y.)--Biography. I. Title.
 F129.W705P36 2007
 974.7'245--dc22
 2007021391

Notice: The information in this book is true and complete to the best of our knowledge. It is offered without guarantee on the part of the author or The History Press. The author and The History Press disclaim all liability in connection with the use of this book.

All rights reserved. No part of this book may be reproduced or transmitted in any form whatsoever without prior written permission from the publisher except in the case of brief quotations embodied in critical articles and reviews.

Contents

Foreword 7
Preface 9
Acknowledgements 11

Quaker Beginnings 13
From Farms to Suburbs 33
A Westbury Education 55
Trees, Flowers and Hicks Nurseries 61
From Horses to Airplanes 71
Post Avenue—The Heart of Westbury 105
Religion in Westbury 129
Westbury Today: Old Meets New 139

Appendix 153
Bibliography 157

Foreword

As time passes, changes are inevitable. Few things are immune to the effects of the passage of time. As you read this account of the history of the village of Westbury, you will get a better sense of what I mean.

Born in 1930, the first child in a family of three children, I was often told interesting stories of the village by my parents. My parents lived in our home in the village at 45 Post Avenue beginning in 1928, after their marriage. I was a Depression baby. As I grew and was able to comprehend, I could visualize the difficult life my parents lived in those early years. Sometimes shoveling snow on Post Avenue was the only form of work my father could find. Mom was able to make a meal out of almost anything. In those years the village, like me, was in its infancy.

Like most children, I marveled at the stories my parents could tell. Dad could remember the politics involved in the incorporation of the village in 1932. He had come to this country from his hometown of Dorno, Italy, as a young boy. Mom, born of Italian parents, was from the village of Floral Park.

Traveling from Westbury to Floral Park to visit as a family in my early years was simple. There was a little traffic in Mineola or New Hyde Park—a far cry from the congestion one encounters today.

In the forties, it was parochial school at St. Brigid's. By my graduation from Westbury High School in 1948, we had already seen the major change in communication media with the twelve-inch black-and-white television sets in some homes. Radio was already on the way out. There was still a hay feed and grain store on Post Avenue, just three hundred feet north of the railroad tracks. People heated their homes with coal furnaces, but the Hicks Coal Yard was already converting to a fuel oil outlet.

Westbury was a friendly place to live. Families knew each other. Parents shopped on Post Avenue, and their kids went to the movies together. The four ice cream parlors on Post Avenue were always doing a big business. Today, we have none. Gone also is the diner, now the site of the Galleria Restaurant. No longer do we have the many stationery stores. Staab's Hardware, Smiles five-and-ten-cent store or Seymour's Textile Store, where you could also get your Boy Scout's uniform, are all gone. How the village has changed!

Starting in 1952, my father worked in the village as a plumbing and heating contractor, in and out of the homes of friends and neighbors. We maintained that family-owned

Foreword

business until his death in 1969. In 1973, I began my service as a trustee on the Village Board of Trustees. In 1981, I was elected to the office of mayor, where I continue to serve in this year of 2007, the seventy-fifth anniversary of the incorporation of Westbury as a village.

Gone today are the Piping Rock and Maple House Restaurants, now the sites of two large condominium complexes. What would those early village residents have thought of such large buildings? What a dramatic change from the little bungalows or two-story frame houses that filled our village parcels through the mid-1940s and early 1950s. Gone also are the empty lots we played in as children. There are no hills or streets to sleigh ride on because of the traffic. And who are those people down the street? Gone are the days when you knew almost everyone around you.

So change continues, and as the years pass, the memories are precious. It is so interesting and warming to go back in time and capture the visions and feelings that we all miss. This book will be about the Westbury I knew, I now know, and have loved all my life.

Congratulations and many thanks to Richard Panchyk for this wonderful gift of memories to me and to the village on its seventy-fifth anniversary.

Ernest J. Strada, Mayor of Westbury

PREFACE

Covering more than 325 years of history is no easy feat. I have tried to include the important people, places, businesses and events in Westbury history, but it is inevitable that some things have been left out, some events maximized while others are minimized. I hope that I have managed to convey the essence of Westbury within these pages. In honor of the village's seventy-fifth anniversary, I have tried to include many photos from the late 1920s and early 1930s.

Westbury has had a fascinating journey from country village to thriving suburban community. Long after this book is published, Westbury will continue to change and grow. It is up to all of us to make sure that we preserve Westbury's wonderful heritage to ensure the future of this historic community.

State of New York
Executive Chamber

Citation

Honoring the 75th anniversary of the incorporation of the Village of Westbury, New York

Whereas, a celebration of pride and public acknowledgment of a community's place in the history of the Empire State draws our citizens together to share a special moment – one which will preserve our rich heritage today and for generations to come; this occasion presents such a moment and an opportunity to participate in a rare event as we join in the 75th anniversary of the incorporation of the Village of Westbury, New York; and

Whereas, New Yorkers are proud to have such a prominent role in the American Dream and the success which has earned our state and nation distinction, as the true greatness of any community is found in its residents and the various social, cultural, economic and spiritual associations that unite them; these cherished relationships are an enduring source of human progress and fulfillment that we all benefit from; and

Whereas, it is recognized by the citizens of the Empire State that each town and village has a singular history that is an outgrowth of events and experiences unique to that period in our state and nation; the rich legacy of Westbury extends back more than 325 years, and includes past events which have shaped its present existence and contributed to the history of this great state; and

Whereas, those persons who have the opportunity to visit Westbury are certain to be delighted in discovering its glory; this occasion is one of pride for all those who have reserved a special place in their hearts for Westbury and is a fitting tribute to the history of a village that has significance for all of New York State's citizens; and

Whereas, best wishes are extended to everyone who has had the privilege to live in and know Westbury and all it has to offer; as the village celebrates this milestone with appropriate festivities, the citizens of the Empire State join in congratulating their fellow citizens of Westbury on this special occasion;

Now, Therefore, I, Eliot Spitzer, Governor of the State of New York, do hereby cite

THE 75TH ANNIVERSARY OF THE INCORPORATION
OF THE
VILLAGE OF WESTBURY

and take this opportunity to offer my congratulations to the Village and its residents and wish your vibrant community a successful and exciting future.

Governor
April, 2007

Acknowledgements

I would like to thank Susan Kovarik and the Historical Society of the Westburys for their gracious assistance from the beginning. Special thanks to Mayor Ernest Strada for sharing his memories of Westbury and for writing the foreword. Thanks to the Westbury Business Improvement District (BID) for their support. Thanks to Peter and Jean Prommersberger for providing their photos and memories and to Caren Prommersberger for her editorial assistance. Thanks to Joseph Proskauer for taking me on a tour of the Westbury Friends complex of buildings and to Noel Palmer for his book on the history of the Westbury Friends School. Thanks to Gretchen Haynes for granting me access to the extensive and very useful digital archives of the Westbury Quakers (see www.westburyquakers.org). Also thanks to the following people who helped me along the way: Joan Boes, Paul Clagnaz, Karen Hicks Courts, Roger Fay, Hilda Finger, Stephen Hicks, Shirley Ingoglia, Ray Muntz, Al Peck, Katherine Powis, Father Ralph Sommer and Ruth Wakeman. Thanks to all those who have previously written materials on the history of Westbury. Thanks to Saunders Robinson and the dedicated staff of The History Press who worked with me on this project. Thanks to the late Ethel Hall, who lived across the street from me, and the late Jean Renison for inspiring me. Thanks to the families who donated materials to the Historical Society over the years, some of which are used in this book. And special thanks to Governor Spitzer for offering his congratulations to Westbury.

Quaker Beginnings

Early History

Native Americans inhabited Long Island thousands of years before the first Europeans reached New York in the sixteenth century. Though Native Americans did not actually live in what is now Westbury, in their travels around the island, the Massapequa did walk paths that coincide with present-day Old Country Road and Jericho Turnpike.

The first European visitor to the area was the Italian explorer Giovanni da Verrazano, who sailed into New York Harbor and explored the Long Island Sound in 1524. It would be decades before the next European ventured into the area. Though Jamestown, Virginia, was settled in 1607, it was not until 1609 that the English explorer Henry Hudson came to the New York area. His primary accomplishment was sailing up what is now known as the Hudson River. He was also the first European to set foot on Long Island. But like his predecessor Verrazano, he did not start a permanent settlement.

In 1614, the Dutch explorer Adrien Block sailed around the entire Long Island and was the first European to map the island. When his ship burned down, he and his crew actually spent the winter on Manhattan Island before sailing back to Europe. A permanent settlement in New York finally came when a Dutch ship arrived in 1624 and founded the city of New Amsterdam at the tip of Manhattan Island. The entire colony was known as New Netherlands.

Following that initial settlement, others came and founded settlements at Fort Orange (Albany), and also at several locations on Long Island. With the settlement of New Amsterdam in the 1620s, competition between the Dutch and the English for control of Long Island heated up. Settlements included Mespat (Maspeth), in 1642, Boswijck (Bushwick) in 1638, Hempstead in 1644 and Vlissingen (Flushing) in 1645. Skirmishes between Long Island settlers and Native Americans made life in the mid-seventeenth century somewhat dangerous. During a nasty conflict known as Kieft's War (1643–1645; named after Governor William Kieft, whose policies fanned tensions between Europeans and Native Americans), some Dutch settlements were decimated, including Maspeth.

In 1650, the Treaty of Hartford was signed between the English and Dutch ceding western Long Island to the Dutch and eastern Long Island to the English. However, when British ships sailed into New Amsterdam's harbor in 1664, Governor Peter

Stuyvesant surrendered. All of New Netherlands was in British control and was renamed New York. At that time, a man named Captain John Seaman owned the land that is now Westbury.

QUAKER BEGINNINGS

Westbury, situated about twenty miles east of Manhattan, was first settled in about 1670 by Henry Willis (1628–1714) and Edmund Titus (about 1630–1715). Henry Willis was born in the town of Westbury, Wiltshire, England. He left Westbury for London in 1667, but was persecuted for his faith and came to the United States with his wife Mary and their children. After living briefly in Oyster Bay, Willis purchased about fifty acres of land from Captain Seaman, a settlement that he named Westbury in honor of his birthplace. Edmond Titus's family had arrived in the New World in about 1635, and during the 1650s, Titus married Martha Washburn.

The two founders of Westbury were members of a relatively new religious group called the Quakers. Like their predecessors, the Pilgrims, who had arrived in Plymouth, Massachusetts, fifty years earlier, they came to America to seek religious freedom. A young man named George Fox (1624–1691) had founded the Quakers, also known as the Religious Society of Friends, in England in the mid-seventeenth century. Among their beliefs was that neither "trained priests" nor formal sacraments or religious rites were necessary for Christians, and that an "inner light" could be found in each person that would help guide them toward spiritual understanding. The Quakers were also opposed to war and did not participate in conflicts. The growing Quaker movement in America got a boost when George Fox himself visited Long Island in 1672 and spoke at Flushing and Oyster Bay.

In the minutes of a Quaker Meeting on May 23, 1671, is the first mention of a Quaker Meeting at Westbury.

> *It was agreed that the first dayes meetings be one day at oysterbay and another day at Matinacock: to begin at or about the 11th houre: and the weekly meeting to begin about the first houre in the aftertoone. It allSo ageeded ther Shall bee a meetting kept at the wood edge the 25th of the 4th [June] month and Soe ever 5th first day of the weeke.*

The "wood edge" (or "plain edge") referred to was the northern edge of the flat Hempstead Plains, where present-day Old Westbury begins and Westbury Village ends. The settlers found this location to be favorable for farming, and through the 1680s and 1690s Westbury continued to grow. From the earliest days of the settlement, families became intertwined through marriages, which were performed in the homes of the settlers. For example, Henry Willis's daughter Mary was married to a New York tailor named George Masters in the family's Westbury home in September 1678. In September 1690, Thomas Powell married Elisabeth Philipps of Jericho in Edmund Titus's house. Witnesses to the ceremony included members of the Seaman, Townsend, Powell, Willets, Wood, Titus, Willis and Dole families.

Quaker Beginnings

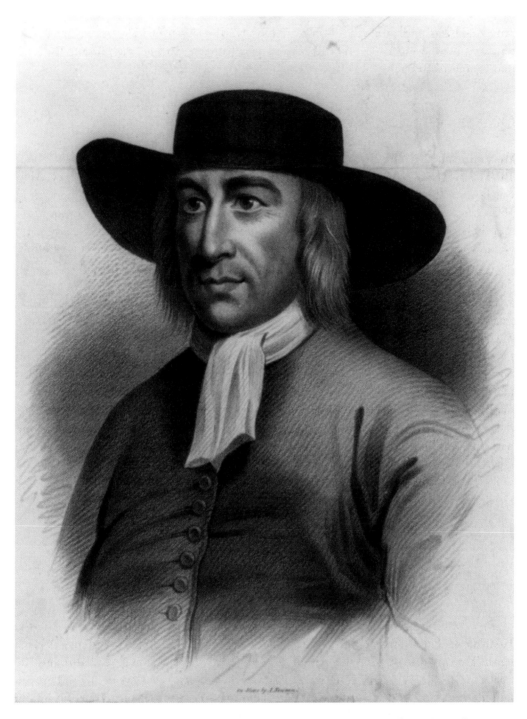

George Fox, founder of the Society of Friends (Quakers). *Photograph courtesy of the Library of Congress.*

A History of Westbury, Long Island

In her nineteenth-century memoirs, Rachel Hicks related a story about her great-great-grandfather John Seaman, who had originally purchased some Westbury land from the Native Americans. The tale (which likely took place in the late seventeenth century) demonstrates the Quakers' commitment to peace and friendship.

> *John Seaman (as he was also captain of the militia) was informed that a large number of Indians were coming to cut off the white people. This brought him a great weight of exercise; but, turning his mind to the Almighty for counsel and direction, he felt prepared to go out with the few white men of the then small village, to whom, although armed, he gave positive orders not to fire on the Indians unless he gave them the order. Thus he met the thousand that were marching toward them, and ordered the head man or chief to stop, and, obtaining from him a promise that the Indians should do no harm, he told them they might go on, and, walking by his side, he perceived the Chief to tremble.*

In 1701, after some years of meeting at the recently constructed homes of some of the local Quakers, the Friends decided to build their own meetinghouse. By this time Flushing (1672) and Oyster Bay (1695) already had their own meetinghouses. A discussion about the construction of a Westbury meetinghouse took place in a November 1701 Meeting of the Friends, as revealed in the minutes:

> *Whereas A Meeting house to be Erected Neere Westberry for Couveinency of friends was Spoken of at the Last Quarterly Meeting in Westberry and the Place to build it on and tearmes of Purchas was then referrd to Nathaniell Pearsall, Thomas Powell, Richard Willis, Benjamin Simons, and William Willis, the Said Psons* [persons] *do report to this Meeting that they have Concluded of a place Suteable, therefore tis reffered to them by this Meeting to Consider of the Moddell of the house, and treat with Som persons about building the Same, and give account: accordingly to Next Quarterly Meeting.*

As the eighteenth century progressed, more Quakers were attracted to the pleasant and lightly hilly land just north of the Hempstead Plains. Westbury through the 1700s was a small and quiet settlement. It continued to be a farming community rather than a town proper. It did not have a central cluster of buildings or a true main street in those first hundred years.

Besides Westbury, monthly Quaker Meetings were also held at Flushing, Gravesend, Matinecock and Hempstead. Until 1695, these meetings fell under the jurisdiction of the New England Yearly Meeting. A New York Yearly Meeting was then held at Flushing until 1777. The Yearly Meeting's location then shifted to Westbury until 1794 due to the Revolution, then it was relocated to New York City. The Quarterly Meeting was held in various locations on Long Island beginning in 1676. In 1746, it became known as the Westbury Quarterly Meeting. The Westbury Quarterly Meeting's location alternated between New York City, Flushing, Westbury, Gravesend, Jamaica and Maspeth at various times.

When the Revolutionary War began in 1775, Long Island, like many places in the colonies, had mixed loyalties. However, once the Americans lost the Battle of Long Island (which took place in Brooklyn) in 1776, British forces took control in New York. Late in

the war, British soldiers and their Hessian mercenaries took quarters at several locations in Westbury, including the homes of several residents and the Quaker schoolhouse. They burned some buildings for firewood. There were occasional skirmishes between Long Island residents and British troops. One incident was recorded "from the lips of Thomas Willis" in a book called *Queens County in Olden Times*:

> *Joseph Willets, of Westbury, was robbed of 30 or 40 pounds, by some soldiers, who lay at Jericho. They maltreated him with a view of extorting more money, till his sister Sarah rushed in to avert the blows from her brother, saying, you will not strike an unarmed woman. On his making complaint to the authorities, the soldiers were drawn up in two rows, and he was ordered to walk between and point out the robbers, but the conscientious and humane Quaker relented and told the officers he could not identify them with sufficient accuracy to have them punished. So they were let off.*

The end of the war brought independence to the colonies, and the United States was born. The fifty-eight-square-mile town of North Hempstead was established in 1784, dividing into two what had previously been the town of Hempstead. Westbury fell under the jurisdiction of the town of North Hempstead.

In the winter of 1800, the attendees of the Westbury Meeting discussed whether to repair the old meetinghouse or to build an entirely new one. It was decided that it "might be well to look toward building a new one" and so they proceeded to tear down the old structure and put up a new one that was to be forty by fifty-seven feet in size. Among those Friends involved in the process were William Willets, Stephen Rushmore, Edmund Post, Gideon Seaman, Jacob Smith, Samuel Searing, Stephen Mott, Charles Frost, Benjamin Beedle and Daniel Titus.

Life in eighteenth- and nineteenth-century Westbury was idyllic. The small farm community thrived. The Quakers were ambitious travelers, and many a Westbury Friend entertained visiting Friends from Pennsylvania and many other states. These visitors would stay for perhaps a day or two with a Quaker family in Westbury, then move on to another Quaker family's house in Jericho, Oyster Bay, Flushing or other communities on Long Island, as they made a grand tour of the area.

These visits to Westbury proved to be both educational and entertaining for the children of the household. As was written about Gideon Seaman, born in Westbury 1744, "His father's [Thomas Seaman] house was much frequented by Friends, particularly those travelling in the ministry, whose company…proved a means of instruction, tending to imbue his mind with the love of virtue, and strengthen his desires to walk in its paths."

In June 1792, Caleb Cresson (1742–1816) a Quaker from Pennsylvania was visiting Jericho and Westbury. He visited William Titus at Westbury, Edmund Willis at Jericho, and then attended the Westbury Meeting. After dinner at William Titus's home, he spent some time at Thomas Seaman's house "a venerable old man…and tho' blind or nearly so, walks to Meetings as they fall in course, without difficulty."

Gideon Seaman's daughter Rachel Hicks (born 1789) would later write in her memoirs about her own childhood:

> *My father's house was a place of entertainment for Friends traveling in the ministry or attending quarterly and monthly meetings. On many of these occasions the company settled in silence, and often counsel flowed sweetly, to the tendering of many minds, especially those of the young. At these seasons, impressions were made in my youthful mind that have never been effaced.*

Some Quakers who were in special circumstances spent longer times with their Westbury brethren. For example, an unmarried and ailing woman named Clements Willets (1709–1772), whose father moved to Pennsylvania in 1736, was shuttled between various Quaker homes. She spent one year at John Titus's house in Westbury in 1747 and then moved on to her cousin Sarah Clement's house in Westbury in 1748.

Likewise, Westbury Quakers also traveled far and wide and were warmly received in the homes and meetings of other Quakers. The more vocal of these Westbury Quakers were able to rouse their audiences; when the Westbury-born minister Rachel Hicks spoke at a Monthly Meeting in Pennsylvania, she gave a rousing speech sounding an alarm to those who were "listless and idle" about the salvation of the soul.

There were also Monthly Meetings of Women Friends in Westbury. In 1775, this group consisted of, among others, Amey Willets, Esther Seaman, Mary Willis, Ann Prior, Mary Post, Phebe Doty, Phebe Hicks, Mary Jackson, Anne Willis and Hannah Seaman.

A Split among the Quakers

A historic split occurred in the early nineteenth century that broke the Quakers into two distinct groups, and Westbury was at the center of the controversy. The renowned minister Elias Hicks, who belonged to the Jericho Monthly Meeting (which fell under Westbury Quarterly Meeting), had for years been traveling far and wide and speaking at Quaker Meetings around the country. However, by the early 1820s, there were some people among the Friends who disagreed with certain aspects of what Hicks preached regarding the Bible. Some of the statements he made that were recorded in books of the time certainly demonstrate their controversy.

For example, at the Westbury Quarterly Meeting in July 1821, Hicks said that "Some parts of Scripture represent Jesus to be the son of Joseph; others, that he was brought forth by a miracle; and there is as much Scripture evidence one way, as the other."

Then, in January 1822, Hicks said to Gideon Seaman in Westbury that the Angel's declaration that Mary carried the son of God in her womb "can't be proved; who said it? It was only Joseph and Mary's testimony, or say so; and it was in their interest to say so; but it ought not to be there."

The issue came to a head in Westbury, at a public meeting on July 29, 1825, just before the Quarterly Meeting was to be held. Elias Hicks was present and he spoke at length. Among the things he said was that Jesus "stood on the same ground, and no higher than other men" and also that "the Scriptures do not properly belong to any,

Quaker Beginnings

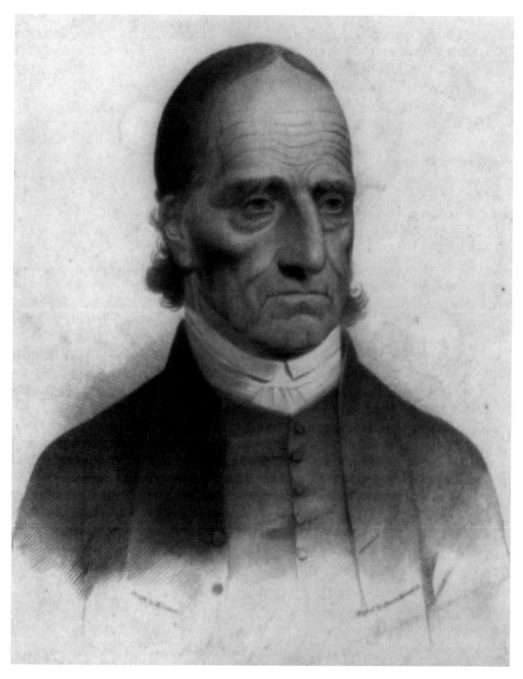

Elias Hicks of Jericho, whose preaching caused a rift among the Quakers. *Photograph courtesy of the Library of Congress.*

but those to whom they were written; they are so far from being any rule to the true Christian, that they are inconsistent and contradictory to themselves, and there is not agreement in them, in any general way."

Upon hearing these and other statements by Hicks, two respected Quaker elders, Solomon Underhill (born 1748 at Cedar Swamp near Westbury) and Gideon Seaman (born in Westbury in 1744), both vocally objected. For Seaman, it was not the first time he had objected to the preaching of Elias Hicks. In fact, Seaman had privately spoken to Hicks on previous occasions to let him know he had a problem with some of Hicks's words. Now, seeing that Elias Hicks continued to preach these same ideas, he felt it necessary to let the audience know that he believed Hicks's ideas did not fit into the Quaker doctrine. Underhill also spoke out against Elias Hicks.

This simple expression of their sentiments was taken by some of the Friends present at the meeting as not only offensive, but also punishable. Elias Hicks had gained many followers, who felt protective of him. Seaman and Underhill were told that such statements should have been made in a private meeting of ministers and elders, not in a public forum such as the Westbury Meetinghouse. Charges were brought up against the two men, who both refused to acknowledge that they had made any error, nor retract what they had said.

For Underhill, the case went on for eleven months, during which time he was not allowed to speak in meetings. While the case dragged on, Underhill's health declined. Early in 1826, he wrote an address to the members of the Westbury Quarterly Meeting, seeking to explain himself and warn of the dangers that lay ahead for the Quakers. He cited a passage from the Bible in his address (which he decided not to publish) "…after my departing shall grievous wolves enter in among you, not sparing the flock. Also of your own selves shall men arise, speaking perverse things, to draw away disciples after them." Underhill believed that the Friends were being tested, but in the frailty of his old age felt powerless to do anything about it. His address was published posthumously in 1827. The case against the men was finally dismissed, but the damage within the structure of the Quakers had been irreparably done.

In 1888, the famous poet and writer Walt Whitman (1819–1892) wrote a piece on Elias Hicks. In the preface, he wrote: "As myself a little boy hearing so much of E.H., at that time, long ago, in Suffolk and Queens and Kings Counties—and more than once personally seeing the old man—and my dear, dear father and mother faithful listeners to him at the meetings—I remember how I dream'd to write perhaps a piece about E.H. and his look and discourses." He wrote of an incident at a meeting in Philadelphia in the 1820s that foretold the separation:

> In the course of his utterance or argument he made use of these words: "The blood of Christ—the blood of Christ—why, my friends, the actual blood of Christ in itself was no more effectual than the blood of bulls and goats—not a bit more—not a bit." At these words, after a momentary hush, commenced a great tumult. Hundreds rose to their feet… Canes were thump'd upon the floor. From all parts of the house angry mutterings. Some left the place, but more remain'd, with exclamations, flush'd faces and eyes. This was

> *the definite utterance, the overt act, which led to the separation. Families diverg'd—even husbands and wives, parents and children, were separated.*

In the 1828 "Separation," a fraction of the Friends broke off from the main body and became known as the Orthodox Quakers. About 9 of the 211 members of the Jericho Monthly Meeting seceded, and about 39 of the 341 members of the Westbury Monthly Meeting joined them to form the Westbury and Jericho Monthly Meeting. This represented about 10 percent of the Friends from those two communities (though the Orthodox numbers eventually increased). While Elias Hicks was traveling, The Monthly Meeting of Westbury and Jericho ordered him to return home immediately and face questions about his character as a minister. Hicks and his followers did not recognize the authority of this newly created group.

The split was a very sad occasion for many Friends. Families and friends unfortunately found themselves on opposite sides. For example, Rachel Hicks was deeply saddened that she could not join her father Gideon Seaman in the Orthodox faith, but she felt strongly that she should remain a Hicksite Quaker. Her disappointed father told her, "It may be I was deficient in thy education." She later wrote that the separation had caused her much "mental suffering."

The Orthodox Friends realized they could not continue to meet in the existing meetinghouse, so they proceeded to build a new meetinghouse of their own in Westbury in 1830. They constructed the small building just across the road from the existing meetinghouse. This historic building is still standing today and is used for classrooms; Post Avenue no longer intersects the Quaker property; it now passes west of both meetinghouses. After the groups had separated, there were still many bitter feelings between the Hicksite Quakers and the Orthodox Quakers. There were even court cases, in one instance over which of the two groups had the right to certain school funds.

During the late 1820s and early 1830s, the war of words escalated. Both the Hicksite Quakers and the Orthodox Quakers published inflammatory books. Each group accused the other of breaking off from their main group. For example, the Orthodox sect of the Friends issued the following statement against Elias Hicks in 1829:

> *Elias Hicks…has indulged in speculative opinions…and has imbibed and adopted opinions at variance with some of the fundamental doctrines of the christian religion; always believed in and maintained by the society of Friends…and has…entertained doubts of many of the important truths declared in the Holy Scriptures…he has extensively promulgated his views in conversation, in writing, and in his public communications…he has insinuated his unsound opinions into the minds of many of the members of our society…he has induced great numbers to embrace them, and has at length become the leader of a sect (distinguished by his name), which first separated from the yearly meeting of Friends in Philadelphia, in the 4th month 1827, on the ground of difference in doctrine, as they state in their printed address. Signed on behalf, and by direction of the monthly meeting of Friends of Westbury and Jericho, held at Westbury the 29th day of the 4th month, 1829. By Valentine Willetts, Clerk.*

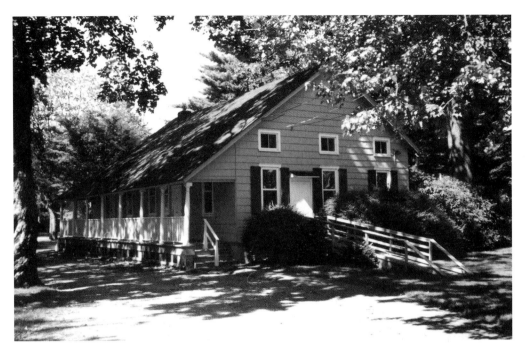

The Orthodox Quaker Meetinghouse, built circa 1830, is used today for classrooms. *Photograph courtesy of the author.*

In response to these accusations from the Orthodox Friends, the Hicksite Quakers wrote the following, stressing the fact that the Orthodox were just a small group:

> *Within the limits of all these yearly meetings great exertions have been used to prepossess the minds of friends against Elias Hicks…in Pennsylvania and in New-York. It is not a matter of wonder or surprise, that many of them should be persuaded that he had departed from the true faith, when they are gravely informed that such is the fact by ministers and elders, and those whom they have been accustomed to behold in the light of fathers in the Church…The true state of the eight yearly meetings on this continent, will claim a brief notice. Of those, that of New-York, was supposed to contain at the time of the separation, nearly 20,000 members, of whom about three-fourths, more or less, adhere to the ancient, established order, and with whom Elias Hicks is in unity. The remaining one-fourth, have separated, in most instances, from the established meetings, of their own choice, and set up meetings of their own…and have been busily employed since the yearly meeting of 1828, going through the sham process of disowning the majority as "separatists," or for having "gone off."*

The newly formed Westbury and Jericho Monthly Meeting was looked upon with disdain by the Hicksite Quakers because, for one, "no such meeting is known in the order of our society." The Orthodox Friends placed the blame squarely upon Elias Hicks for the separation. Thomas Willis wrote in 1831, that, "Elias Hicks was instrumental in producing a sorrowful schism in the Society of Friends."

Quaker Beginnings

Though Elias Hicks died in 1830, the two Quaker groups were formally reconciled only in 1955, after more than 125 years of separation.

AFRICAN AMERICANS AND THE QUAKERS

The Quakers were quite progressive in their ideas about the treatment of African Americans. In 1671, Quaker founder George Fox and other Friends paid a visit to the island of Barbados, where he observed slaves. While there, he met with the slaves. He wrote of the visit: "I desired also that they would cause their overseers to deal mildly and gently with their negroes, and not use cruelty towards them…and that, after certain years of servitude, they should make them free." In 1675, another Quaker, William Edmondson, visited Barbados and said: "Did not God make us all of one mould?…Christ's command is, to do to others as we would have them do to us; and which of you would have the blacks, or others, to make you their slaves, without hope or expectation of freedom or liberty?"

So it was that before anyone else was even considering the emancipation of slaves, the Quakers were already doing it. During the 1770s, nearly ninety years before President Abraham Lincoln would sign the Emancipation Proclamation, the Quakers of Westbury Meeting and elsewhere began to free their slaves, filling out and registering "manumission papers."

These papers typically read:

> *Be it Known to all men by these presents that I (name), of (place), in Queens County, and province of New York do by these presents fully freely and voluntarily manumit and set free my Negro man named (name) fully and freely acquitted and Discharged from me and my heirs Executor and Administrators forever, and that the Said Negro named (name), Shall and may as far as in my power Exercise and enjoy his freedom in all Respects, to all Intents and purposes Whatsoever.*

The Westbury Meeting alone registered ninety such manumission papers in just the years 1776 and 1777. Phebe Dodge (born Willets) set her slave Rachel free in 1776. Rachel Hicks's grandfather Thomas Seaman (died 1804) had bought a slave as a young man, but was not pleased with him and so sold the slave. Later, when the Quakers decided to make a stand against slavery and began to free their slaves, he bought that same slave back solely in order to free him. In 1778, Elias Hicks set a slave named Ben free.

Beginning in 1788, New York state began to pass laws that chipped away at slavery, and by 1841, all slaves in New York state were freed. During the nineteenth century, Westbury and Jericho played major parts in the legendary Underground Railroad. The building in Jericho that presently houses the Maine Maid Inn belonged to Valentine Hicks and had a secret attic room where runaway slaves could hide as they made their way north and out of reach of those who sought to catch them.

In 1794, the Charity Society of the Jericho and Westbury Monthly Meetings was established to benefit the poor members of the local African American community.

A History of Westbury, Long Island

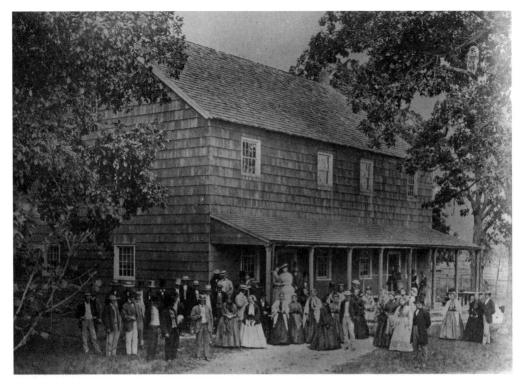

The Westbury Meetinghouse (built 1800) as it appeared in 1869. *Photograph courtesy of the Historical Society of the Westburys.*

It had thirty members when it was formed, including six women. The three biggest contributors were Elias Hicks, Fry Willis and Joseph Cooper. The African American community known as Grantville centered around the intersection of Union Avenue and Grand Boulevard (mainly south of Union and west of Grand). Some of the early families who lived in Grantville were Willetts, Harris, Jackson, Tredwell, Pursor and Ketchum. One of the most respected and well-known black families was the Levi family. Eliakim Levi was a well-known family member; he helped assist former slaves get to Canada via the local Underground Railroad. Townsend Levi (born 1834) was the patriarch of the family during the late nineteenth century.

In 1839, a group of the Hicksite Quakers formed the New York Association of Friends for the Relief of Those Held in Slavery, to support anti-slavery activities in the area. The Quakers continued to support the African American community even after Abraham Lincoln's Emancipation Proclamation.

Quaker Life in Turn-of-the-century Westbury

During the late nineteenth century, Quakers were still in the majority in Westbury, but their farms were quickly being bought out by wealthy industrialists and financiers, and

Quaker Beginnings

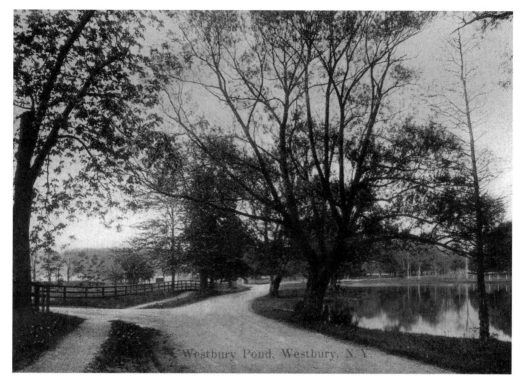

Westbury Pond, Old Westbury, early 1900s. *Photograph courtesy of the Historical Society of the Westburys.*

the land south of Jericho Turnpike was being settled by Irish and German immigrants. Even then, Quaker life was still very important in Westbury, and the Friends remained a close-knit community. The Westbury Friends were also very connected to Friends everywhere. In one old Westbury house that belonged to local Quakers, several issues of an 1897 magazine called "The British Friend" were found.

Even the Quakers were not completely isolated from tragic or violent incidents. In 1885, Ella Whitson, the wife of the prominent Westbury Friend Frederick Willets shot and injured her husband and tried to kill herself. The headlines from the newspaper story read: "A Wealthy Quakeress Insane."

In 1902, the one-hundred-year-old Westbury Meetinghouse burned down. Esther Hicks Emory (1902-2004; daughter of Henry Hicks) recalled:

> *They held the first Meeting for Worship* [in the present Meetinghouse] *when I was just a month old, in 1902. When the other meeting burned, my cousin Ralph was eight years old. They let him out of public school to watch the Meetinghouse burn. They thought that there had been some embers in the stovepipe and the pipe broke during the week. It burned to the foundation so it wasn't worth repairing. There were very detailed plans of the old meeting so they built it the same. They built it right away, as fast as they could.*

By the early twentieth century, the broad-brimmed hats of old were mostly gone, as was the horse-drawn carriage. A *New York Times* article from 1907 explained how several Friends now came to the Westbury Quarterly Meeting in "fast-traveling automobiles." Nevertheless, though times had changed, the Quarterly Meeting at Westbury was every bit as important an occasion as it had been one hundred years earlier. For many Friends, it meant overnight visitors. Preparations for the meetings were carefully made. Everything from food to flower arrangements had to be prepared.

A rare glimpse into Westbury Quaker life at the turn of the century comes from recently discovered correspondence written between about 1893 and 1900, most likely between Alice Albertson, the second wife of Benjamin D. Hicks (1836–1906) and Lillian Barker, the second wife of Gilbert Hicks (1838–1922).

Alice: "Did thee go with Gilbert on thy bicycle or in carriage? The paths are better than the road for bicycling I think."

Lillian: "Gilbert went with me to pass your house and we saw the painter on it. I hurted [from] the jarring of the wheel. I was tired of it. My cousin Helen lent the vibration to me. She wanted me to try it. I used it two times. I slept well and did not made my hip pain [worse]."

Alice: "Yes, we are having our house painted the same color it was before. We had a bay window put on the cottage in the woods along the Roslyn Road. We take our work into the woods sometimes on pleasant days. I can handle a hatchet a little and sometimes cut down partly dead trees in the woods and make piles of wood to be carried away. We have two nice seats in the woods that Benjamin built, and I painted them. It makes the perspiration rain down off me—which is good."

Lillian: "I am glad to see you. I do not feel well. The damp makes my hip [hurt]."

Alice: "I had been wanting to come for a long time, but always so busy could not seem to get away. We have [been] reading proof today for the old Records of the Town [Besides compiling a Hicks genealogy, Benjamin Hicks also published ten volumes of Hempstead Town Records], but finished all we had on hand so Benjamin felt he had not been at Cocks' in a long time and I called him Wednesday on my way home from the Turnpike beyond Mrs. Hones place where I rode with Benjamin on his way to the bank meeting, and I walked home so I said if he would walk to Isaac Cocks, I would call for him on my way back from my call with thee. I am so sorry thy hip troubles thee. Does it feel well in pleasant weather when the sunny days are here? We have had such an unpleasant June. Our fine strawberries rotted on the vines, being all soaked with rain, and we have not had anything as many as usual. Did you have many here? I bought some quarts of strawberries from William Whitson. Are the cherries plenty this year?

Quaker Beginnings

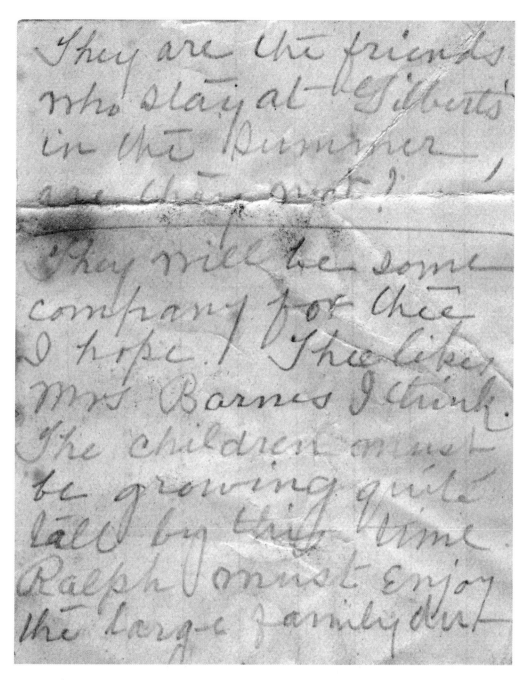

Part of a note written by Mrs. Benjamin D. Hicks to Mrs. Gilbert Hicks, late nineteenth century.
Photograph courtesy of the author.

We have a tree in the garden quite full but they are not a very nice kind. I fear Benjamin will miss his cherry puddings this year."

Alice: "My cousin Sarah Willis visited here and stayed here three days. She went to Syosset. She felt bad because she did not see her and she was shocked to hear my mother's death. She loved to come here…She was not able to come to the funeral. She is 86 years old. My mother always corresponded with her. My mother will be missed from the Quarterly Meeting."

Alice: "Fred Sharpless [1866–1951] and Carrie [1866–1939] will go to Alaska this month. Carrie Sharpless will be quite a traveler soon; she has been on many trips already. Will the little boy Paul go with them or remain with his grandmother? I saw Mariana and Carrie pass with a team of horses."

THE FRIENDS CEMETERY

The Friends Cemetery on Post Avenue is one of the oldest and most attractive cemeteries in Nassau County. The exact date it was founded is uncertain, but it is believed that the cemetery dates to around the time when the first Quaker meetinghouse was built in 1702. The earliest graves were unmarked. There is record of a John Feake, who died during the early eighteenth century and was buried in the Westbury Friends cemetery without a gravestone. The size of the cemetery was increased in 1749, and then again several times more, in 1764, 1855 and 1875. The enlargement in 1875 consisted of three or four acres that were bought from Richard and Mary Willets. The earliest marked graves date to the mid-1700s, with the oldest marked stone reading simply "E-S, March 30, 1744."

Numerous graves date from the early to mid-nineteenth century. The cemetery is a pleasant place, dotted with numerous old trees. Those people buried in the cemetery include numerous members of old area Quaker families including the following names: Albertson, Carle, Cocks, Doughty, Gardner, Griffin, Hallett, Hallock, Hawxhurst, Hicks, Hollett, Layton, Lewis, Patterson, Post, Pritchard, Rushmore, Schwicker, Seaman, Sharpless, Sprague, Titus, Turrell, Valentine, Weeks, Whitman, Whitson, Willets, Willis and Wilson. Among the many Hicks family members buried there are Isaac Hicks (1815–1900), Henry Hicks (1870–1954), Edwin Hicks (1906–1992) and Alfred Hicks (1940–2004), owners of the Hicks Nursery. During the Separation, the Orthodox and Hicksite Quakers continued to be buried in the same cemetery. In the 1880s, a section of the cemetery was designated for African American burials, but later these burials were spread throughout the cemetery.

PROMINENT WESTBURY QUAKERS

Many Westbury Quakers were prominent within their community, but several also became prominent on a larger scale. A few of these famous Westbury Quakers are described below.

Quaker Beginnings

Isaac Hicks

A Hicks family ancestor, Elias Hicks of England, was knighted for courage on the battlefield in 1356. Since then, the Hicks family has been prominent. The Hicks family arrived in the New World in 1621, and was on Long Island as early as 1642. Isaac Hicks (1767–1820), a descendant of the original Long Island branch, was raised in Westbury, but left Westbury at the age of twenty-two. He decided to head off to New York City to enter the business world, along with his brothers Samuel and Valentine. On his person, he had a letter of recommendation from Gideon Seaman, the Clerk of the Westbury Meeting. He began work as a tailor (the trade his father Samuel had back in Westbury), but moved on to the grocery trade and then on to more valuable goods. By 1790, he had a business with a partner, called Alsop and Hicks. He eventually owned trade ships that carried cotton and tobacco to foreign ports. Because of the wealth he had accumulated, he was able to retire in 1805, when he was just thirty-eight years old. He returned to Westbury and became clerk of the Westbury Meeting from 1816 to 1820. Isaac's brother, Valentine, (a member of Westbury Meeting) lived in a Jericho house (built 1789) that is still standing today as the Maine Maid Inn restaurant. Isaac Hicks's later namesake (1815–1900) was the founder of Hicks Nurseries (see Chapter Four).

Edward Hicks

Not technically a Westbury Quaker, Edward Hicks (1780–1849), a Quaker minister and painter who lived in Pennsylvania, was a cousin of the Westbury branch. His most famous works include a series of paintings titled *The Peaceable Kingdom*, based on a verse in the Old Testament by Isaiah. These paintings depict the purchase of land from the Indians by the Quaker William Penn. Today his paintings command top dollar on the market. Though not from Westbury, he had connections to Westbury. Edward Hicks wrote of a visit to Westbury Meeting in 1820. In 1846, he recorded in his diary that his "very dear grand daughter, Phoebe Ann Carle" had died and was to be buried at the Westbury Friends Cemetery, next to "her dear little brother Silas."

Isaac Post

Isaac Post (1798–1872) was born in Westbury and educated at the Quaker School in Westbury. He became involved in the drug business, but relocated with his family to Scipio, in upstate New York in 1823, not long after the birth of his daughter Mary. In 1836, he moved to Rochester. He soon left the Quakers because he felt their stand against slavery was not strong enough. Post became active in the anti-slavery movement in Rochester. He was friendly with the abolitionist William Lloyd Garrison and the African American leader Frederick Douglass. He was also interested in women's rights.

Besides his anti-slavery activities, Post also became very interested in spiritualism. He was also the author of a celebrated book called *Voices from the Spirit World, being Communications from Many Spirits, by the hand of Isaac Post, Medium* published in 1852. This book consisted of writings supposedly channeled through Post from famous men such as George Washington, Thomas Jefferson, John C. Calhoun, Elias Hicks, Edward Hicks, William Penn (the Hicks cousins and Penn were all Quakers), Voltaire and Benjamin Franklin.

At one séance, Post called upon the spirit of William Willets (died 1841), formerly of Westbury, to advise his son George on the merits of moving to Michigan.

Isaac Post died in Rochester and was buried in the Mount Hope Cemetery in Rochester. Isaac Post's brother Joseph Post (1803-1888) was also an abolitionist. Born in Westbury, Joseph chose to remain there his whole life.

Elias Hicks

As described earlier, Elias Hicks (1748–1830) was a very well-known member of the Hicks family. As he wrote in his autobiography, "I was born in Queens County, Long Island, on the north side of the great plains, generally known by the name of the Hempstead Plains, about three miles west of the meetinghouse at Westbury." He married Jemima Seaman at the Westbury Meeting in 1770 and then moved to her family's property in Jericho. He became a Quaker minister and traveled extensively, as far south as Virginia and as far west as Indiana. His name is one of the most prominent in the entire history of the Quakers; Elias Hicks was the inadvertent founder of the Hicksite Quakers.

Rachel Hicks

Rachel Seaman Hicks (1789–1878) was born in Westbury, the daughter of Gideon and Elizabeth Seaman. She was married in 1815 to Abraham Hicks, the nephew of the famous Elias Hicks, but her husband died young in 1827. She also lost two of her three children. Though for many years she was shy and did not even venture to speak at the Westbury Monthly Meeting, Rachel Hicks eventually found a calling to the ministry. By the late 1830s, she was traveling widely, visiting Friends in Philadelphia, Baltimore, Ohio, Indiana, Illinois, Michigan and points farther west. She was away for months at a stretch. "I have made no account of the number of miles I have traveled, or meetings I have attended, fearing it might seem like boasting," she wrote in her journal.

She was eager to travel, yet she also missed Westbury. In 1855, she wrote, "Far away from home and all I love there, there is some satisfaction in conversing with them by pen. Oh, how I want to hear from all of you there, I hope no afflictive circumstance has occurred in dear old Westbury." In one of her last letters, she wrote, "I traveled frequently from home, visiting all the meetings belonging to our part of the Society of Friends, and some of them twice over. Whether it has ever done any good to others I

Quaker Beginnings

William Willets Cocks's signature in a schoolbook, 1874. *Photograph courtesy of the author.*

leave to Him who sees the heart, but through His mercy, I feel that it has thus far saved my own soul." Her death in 1878 was covered in a brief story in the *New York Times*, titled "Death of an Aged Quaker Lady." Her namesake, Rachel Hicks (1857–1941), was a noted photographer and founder of the Neighborhood House.

WILLIAM WILLETS COCKS

William Cocks (1861–1932) was a politician born in Westbury, brother of Frederick Cocks Hicks. He was elected commissioner of highways of the town of North Hempstead in 1894. He served in that capacity for six years. He was then elected to the New York State Senate in 1901 and 1902 and was a member of the New York State Assembly in 1904. He was elected to a seat in Congress in 1904 and was re-elected twice. Among his accomplishments, he was a member of the board of managers of Swarthmore College; president of the Friends Academy, Locust Valley, Nassau County; vice president of the Roslyn Savings Bank; a director of the Bank of Westbury and the Bank of Hicksville; served as mayor of the village of Old Westbury from 1924 until 1932. He was also a close friend of Theodore Roosevelt.

FREDERICK COCKS HICKS

Frederick Hicks (1872–1925) was born Frederick Hicks Cocks in Westbury. He was adopted by Benjamin D. Hicks and took that name. He ran for Congress in 1912, but lost. He won election in 1915 and was re-elected twice. He served as eastern director of

the Republican National Committee campaign in 1924 and was appointed by President Calvin Coolidge as a member of the commission to represent the United States at the celebration of the centennial of the Battle of Aracucho, held at Lima, Peru, during December 1924. He was then appointed Alien Property Custodian in April 1925 and served in that capacity until his death in Washington, D.C., in December 1925.

Samuel Willets

Samuel Willets (1795–1883) was born in Westbury and moved to New York City, where he started a successful hardware business called Willets & Co. He was listed in a nineteenth-century book called *America's Successful Men of Affairs*.

FROM FARMS TO SUBURBS

Before the 1850s, the majority of Westbury's population (mainly Quakers) lived north of Jericho Turnpike. The early settlers of Westbury south of Jericho Turnpike came primarily from Ireland and Germany during the 1800s. The development of Westbury village south of the turnpike really began with the famines and political strife that hit Ireland and Germany beginning in the late 1840s. From then through the 1860s, Irish and German settlers were the primary tenants of Westbury land.

Until the late nineteenth century, Westbury was known mainly for two things—its Quakers and its farming. An 1839 history of Long Island had only this to say about Westbury:

> *Westbury is a rich agricultural district, between Jericho and the court-house, level and fertile; a majority of the inhabitants are Friends, and have two places for religious worship; the one of ancient date, the other erected within a few years, occasioned by the unhappy divisions now existing among this respectable fraternity of Christians.*

An 1845 guide to Long Island said, "Westbury is a succession rather than an aggregation of dwellings" while an 1860 guidebook called it "a farming neighborhood…the people in this vicinity are chiefly employed in furnishing milk for the New York market."

Clearly, the coming of the railroad line through Westbury on its way to Hicksville in the 1830s had not changed the rural character of the settlement. At that point, farming was the dominant way of life. One event that took place in the early part of the nineteenth century on the Hempstead Plains near Westbury was the annual sheep parting. During this fall event, farmers gathered at the Hempstead Plains to collect their sheep, which had been grazing during the spring and summer. It was a social event with drinks and food, such as corn, watermelon and oysters, for sale. There were also a variety of amusements, dancing, clowns, races and speeches.

In 1864, the village of Westbury, through Isaac H. Cocks, donated $534.85 to the Brooklyn and Long Island Fair of 1864. The nearby Queens County Agricultural Fair was held at Mineola during the 1800s and attracted thousands of spectators from near and far, including many farmers from Westbury.

Advertisement for the Cream Blossom Dairy. Westbury was known for its dairy farms. *Photograph courtesy of the author.*

An 1877 guide to Long Island had this to say about Westbury:

Only a few dwelling-houses can be seen from the depot—but the appearance of the soil shows that it is of a highly productive nature. Much of it is grazing ground. The superior quality of the milk sent from here is an evidence of the richness of the pastures. The early settlers were Quakers, and the present generation still retain the proverbial exclusiveness of their sect.

On the other hand, the same book said about nearby Hicksville that it was a "thriving, well-to-do, country town" and about Mineola that it was "an important junction."

Still, quiet Westbury had nothing to be ashamed of; Westbury farmers were quite proud of their agricultural prominence. At the 1893 Mineola Fair, held at the end of September, several Westbury farmers won prizes for their entries. George Clark won a second prize of twenty dollars for his display of cattle and a second prize of ten dollars for his herd of milk cows. Edward Whitson won a second prize of five dollars for his swine, and W.E. Whitson won a first prize of ten dollars for his Berkshire sow. H. Hicks of Westbury won five dollars for "various turnips." In February 1895, a "Farmers' Meeting" was held at White Plains, New York. Among those who spoke to the audience was Thomas Griffin of Westbury, who talked about "Mushroom Culture."

By the late nineteenth century, farms dotted the land both north and south of Jericho Turnpike. Some of the nineteenth- and early twentieth-century farming families within

the boundaries of present-day Westbury Village included Seaman, Losee, Powell, Pratt, Griffin, Covert, Lewis, Post, Scally, Roach and Latham.

Once an actual rail station was built in 1883, more stores popped up, but for the most part this settlement south of Jericho Turnpike was still minimal. Westbury Station, as it was known, was a relatively sleepy hamlet. In 1895, the population of Westbury Station was 365. By 1902, the population of Westbury Station had reached 400, more than the population of Old Westbury at 375. This compared to nearby Mineola with a population of 900 and New Hyde Park with a population of 500.

A post office for Westbury Station was finally established on Post Avenue in 1882, with Edward Kelsey serving as the first postmaster. What kind of letters did the early residents mail? One piece of mail postmarked from Westbury in 1884 was a note sent to a doctor in another town. It was written by a woman living on the farm of William Wood (just south of the village), who asked, "Will you come to see my mother?"

In 1898, the western part of Queens County was annexed by New York City. Benjamin D. Hicks of Westbury led the charge to create a new county out of the remnants of Queens that were not absorbed into New York. After some local debate, Governor Frank Black signed his proposal into law. As of January 1, 1899, Westbury became part of the brand-new Nassau County.

The name of the settlement was officially changed from Westbury Station to Westbury in 1908, while the area north of the Jericho Turnpike became more consistently referred to as Old Westbury.

A Sleepy Hamlet Wakes Up

Toward the end of the nineteenth century, change came rapidly to Westbury. As the Industrial Revolution kicked into high gear, owners of steel and other conglomerates, as well as bankers and financiers, made out like bandits. These newly minted millionaires had plenty of money to burn. Many of them preferred to have a residence somewhere near the financial capital of the world, New York City.

Well-known millionaires such as Morgan, Phipps, Vanderbilt, Guggenheim, Whitney, Mackay, Pratt, Coe, Frick and many others turned their attention to the rolling land north of Jericho Turnpike, developing everything from former Quaker farms in Old Westbury (the Phipps's Westbury House) to waterfront property on the North Shore (Harry Guggenheim's Falaise at Sands Point). For the most part, they stayed away from the flat Hempstead Plains or the swampy south shore and focused on the pleasantly hilly area to the north. The polo and hunting that Westbury offered were attractive to the city folk.

These millionaires hired the most prominent architects of the day to design palatial homes with vast hallways and dozens of high-ceilinged rooms. They were to sit proudly on many acres of carefully groomed land, closed in by great iron gates. Once the designs for these palaces were meticulously laid out on paper, down to every last detail, builders came in and brought the architects' visions to life. Imported

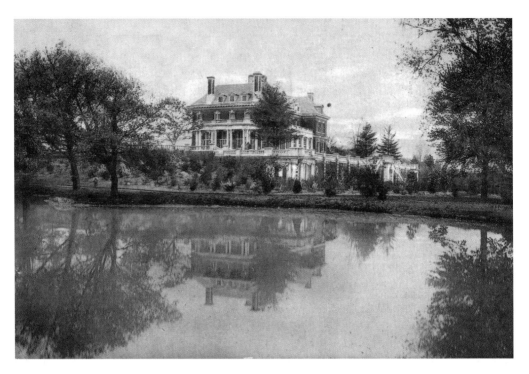

The mansion of John S. Phipps (today part of Old Westbury Gardens), circa 1910, a few years after its completion. *Photograph courtesy of the Historical Society of the Westburys.*

blocks of fine stone and elaborate stone carvings were needed for the exterior, while carefully carved wood panels, frescoes and other fine craftsmen's touches were utilized inside.

Carpenters, plumbers, painters, plasterers, electricians, masons and other craftsmen were needed by the dozens to complete each of these huge structures. Beam by beam, brick by brick, stone by stone, they worked hard at their craft day in and day out. One of the most well-known builders of the early twentieth century was John R. Hill (born 1872), whose contracting operation employed many Westbury men.

Numerous landscapers and gardeners were needed to lay out and plant the elaborate gardens that were sometimes designed by some of the top landscape architects of the day. Many of these gardens were supplied with a wide variety of fully grown trees and shrubbery from Westbury's Hicks Nurseries. In fact, Hicks supplied the great beech tree on the west porch of the Phipps house.

Situated between Post Road and Ellison Avenue, the John Shaffer "Jay" Phipps (1874–1958) House, also known as the Westbury House, was one of the closest of these mega-mansions to Westbury Village. Begun in 1904, the Charles II-style home was designed by the British architect George Crawley in collaboration with the American architect Grosvenor Atterbury. Phipps had purchased 175 acres of Quaker farmland, including the old house that originally belonged to John D. Hicks, the father of Hicks Nurseries founder Isaac Hicks.

From Farms to Suburbs

By early 1907, the Phipps house was mostly complete and ready for occupation. Like most mansions, the Phipps house was not simply a day-labor project; it provided long-term jobs. In 1910, the Phipps household employed more than a dozen live-in footmen and maids, not including hired help that did not live on the premises. Another wealthy Westbury estate owner, polo player Thomas Hitchcock (1861–1941), employed twenty-one on-premise servants, including a nurse, butler, bellboy, seamstress, coachman, groom, stable boy, chambermaid, laundress, waiter and housekeeper.

Even after completion, many houses still required the regular services of skilled maintenance men of all types. Everything from tree surgeons to chauffeurs was needed. The owners of many of these estates continued to have major work done over the years—a variety of additions and renovations, including new buildings on the property, and landscaping work such as terraces and patios.

With regular, good-paying work assured over the long term, a good many of these estate workers bought land just to the south of Jericho Turnpike, in the flat area at the village that was called Westbury Station at the time. During the first three decades of the twentieth century, they built homes on land that had been farmland not long before, and had only recently been laid out with streets.

The old Quaker farms that just a few years before had been dominant north of Jericho Turnpike were all but gone by the early years of the twentieth century. Though many of the old buildings remained on the properties and thousands of acres of fields lay untouched, the vast majority of the old Quaker land was now in the hands of wealthy new owners.

To the south, sales of Westbury Station land were brisk even as early as the turn of the twentieth century. It became more lucrative to develop the land than to farm on it, a trend that would continue on Long Island over the next hundred years. In 1900, forty-four acres of land along Maple Avenue sold for $8,500 after the death of its owner, Newbury Frost. In 1907, the forty-five-acre Besold Farm on Jericho Turnpike and the twenty-acre Seaman farm on Union Avenue were sold. By 1910, a neat grid of streets had been laid out off of Post Avenue in what is now known as the West Village, but whole blocks still lay untouched by development.

In the early years of the twentieth century, farms still coexisted with the newly forming residential community. Esther Hicks Emory (1902–2004) lived in the family's house on the Hicks Nurseries property as a child. She recalled:

> *We had cows on at home. And they were staked out on the lawn, if you can imagine that. So we'd have great circles of cut down grass…Even though we weren't on a farm, we had to have cows for all that milk…Another early thing we had was smokehouses for that times in the winter when they'd slaughter the cattle and cut them up…Once a cow got loose and came tearing around the house.*

One of Westbury's most prominent farmers around the turn of the twentieth century was Wilbur R. Lewis. Born in 1846 in Brooklyn to parents of Welsh descent, Wilbur's father, Epentus, moved his family to Westbury in 1851 and bought a farm west of what

is currently Post Avenue and south of what is now Asbury Avenue. Epentus Lewis died in 1886 and his son continued to live in the farmhouse. By 1900, Wilbur Lewis and his wife, the former Hester Vaneman (born 1848) owned fifty acres of farmland in Westbury. They lived there with their daughters Sarah, Willetta and Hester, two boarders and a servant. Lewis was a trustee of the school system and active in the Methodist church. A book of the time called Lewis "a man of excellent standing in his community…a man of honorable and upright character" who "treats all men justly and fairly."

Just a few years after 1900, Lewis's farmland was sold off for development. Once sold, the former farm's newest crop was houses, which seemed to spring up from the ground at an amazing rate. Lewis Avenue, on property that used to be part of the farm, was named for the old farmer. The names for Liberty Avenue and Wilson Avenue (after President Woodrow Wilson) were vintage World War I.

Though today we may look back upon those times in the Westbury of one hundred years ago as the simpler days, everything is relative. At the time it seemed as if change was happening all too fast. In the landmark 1902 book *History of Long Island*, it was written about the town of North Hempstead that:

> *The quaintness and simplicity of the days agone have disappeared, giving way before the spirit of a new age. The town has moved steadily into those industrial pursuits which necessitate the whirr of machinery and the incoming of a new population—some factory operatives, and others, men of means and comparative leisure with whom the automobile has become a necessity.*

A Fire Department is Created

In March 1897, Westbury citizens in the growing community attended a meeting to address the need for a fire department. It was agreed upon, and the Westbury Hook and Ladder Company No. 1 was created. Frank Powers was named president and Wallace Hawxhurst vice president. The fire department's finance committee raised $471 within two months and set out to acquire fire-fighting equipment. The fire apparatus committee visited various existing fire departments in Queens and Brooklyn, and found that the Gravesend Hook and Ladder Company was willing to part with a used truck for three hundred dollars. This equipment, top of the line for its time, had a 35-foot ladder and 150 feet of discharge hose. The Westbury fire department was able to purchase the truck for a discounted price of $255, and even got free transportation to its new home in Westbury via the Long Island Rail Road in August 1897.

The department also had to find a suitable home. The property that was selected, on the east side of Post Avenue near the intersection with Maple Avenue, was bought from Wallace Hawxhurst for a price of two hundred dollars. The second fire that the department fought, in 1898, was at the home of the wealthy C.H. Mackay several miles north in Roslyn.

Unfortunately, fire played a role in the development of early Westbury. In December 1900, a fire destroyed the stable of Frederick Gebhard, but his horses and carriages

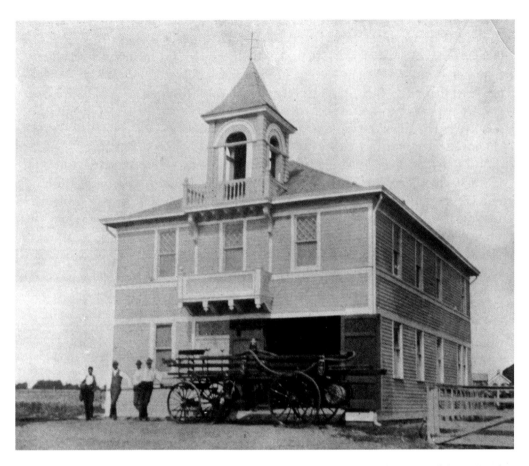

The original Westbury Firehouse, built 1897, was on Post Avenue. *Photograph courtesy of the Historical Society of the Westburys.*

were rescued. In 1902, the Friends Meetinghouse burned down, and on the evening of December 3, 1904, a major fire swept through the village and destroyed all but four buildings in the vicinity of the train station. The fire, which started at Christ's blacksmith shop, soon spread to a hotel, a feed store, a barbershop and a clothing store. Neighboring towns sent support to help get the fire under control. Thousands of spectators gathered and watched in horror as the flames leapt high into the air. As a result of this fire, there was a movement to establish cisterns in Westbury specifically for use by the village firefighters. In 1912, a hose apparatus was bought and the department formed a Hose Company No. 1.

The first fire chief, H.A. Berger (active since 1897), was elected June 6, 1913. Many of the early members of the fire department were among the most well-known and well-respected citizens of town. These included S.M. Barley, L.I. Deferrari, John Deferrari, John Dowling, William Hawxhurst, John Knipfing, Wilbur Lewis, John Luessen, Joseph McKenna, Peter Post, Sidney Pratt, John Renison, Thomas Renison, Fred G. Hicks, Henry Hicks, Valentine Wickey, R.D. Winthrop and Christian Schwicker, among many

others. Before long, Ladder No. 2 and Hose No. 2 were formed, for a total of four companies.

Early on the morning of July 11, 1926, tragedy occurred for the Westbury Fire Department. Firefighter Tom Malaney was killed and fire chief Thomas Walsh was injured when their fire truck skidded and crashed on the way to a fire.

The equipment the fire department has had over the years included an American LaFrance 750-gallon-per-minute pumper truck, bought 1917, a 1925 REO hose and chemical truck, a 1918 Ford Model-T chemical truck, a 1935 American LaFrance pumper, a 1947 Mack pumper and a 1958 floodlight truck.

The fire department has continued to grow since those early days, responding to the needs of a community whose population was less than four hundred when it was formed, but more than fourteen thousand today. It moved into a spacious new building on Maple Avenue in 1932.

Homebuilding Boom

As more and more homes went up during the late nineteenth and early twentieth centuries, essential infrastructure began to be built in Westbury. Electricity was first installed along Post Avenue in 1902. Next, the Westbury Water District was established in 1914 to provide these customers with groundwater from the aquifers in the ground (Westbury's water has been judged one of the best tasting on Long Island). A water tower stood for many years at Drexel Avenue, until it was torn down in 1978.

The first great wave of homebuilding south of Jericho Turnpike occurred between about 1905 and 1915. In 1910, William W. Cocks and F.C. Hicks bought ninety-two lots in New Cassel, which got its name from the Hessian mercenaries who stayed there during the Revolutionary War (named after the area in Germany called Hesse Kassel). In 1915, thirty-two 25- by 100-foot lots in various locations around Westbury were sold at auction. All around the village, from Butler Street to Belmont Avenue to Rockland Street, new homes were being built.

Another wave of Westbury homes was built between about 1920 and 1930. The earliest homes tended to be (with a few exceptions) small to mid-sized Victorians and an occasional Dutch Colonial, while the homes built in the 1920s and early 1930s tended to be large, center-hall Colonials. These were oriented lengthwise on their lots, with a front door and staircase at the center, and rooms to either side.

Many of these attractive early houses had three or four bedrooms, with an outhouse in back. They most often had two full floors of living space, with an unfinished or semi-finished attic and basement. Lot sizes varied from about 25 by 100 feet to well over 100 square feet. Unlike homes that were being built at the same time en masse by the developer Cord Meyer in Queens, each of these houses was markedly different from one another. Because many of the new homeowners were carpenters, plumbers and handymen, their homes were likely to feature extra touches such as pocket doors and built-in cabinets.

From Farms to Suburbs

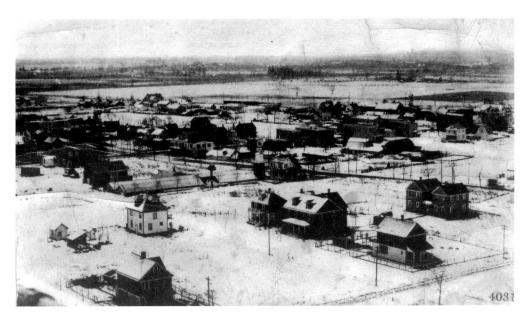

Grand Street (foreground) and Maple Avenue, 1912, seen from the Drexel Water Tower. *Photograph courtesy of the Historical Society of the Westburys.*

Few homes still retain their original wood siding. Shown here the cedar-shingled Dutch Colonial James Topley house, built circa 1913. *Photograph courtesy of the author.*

A History of Westbury, Long Island

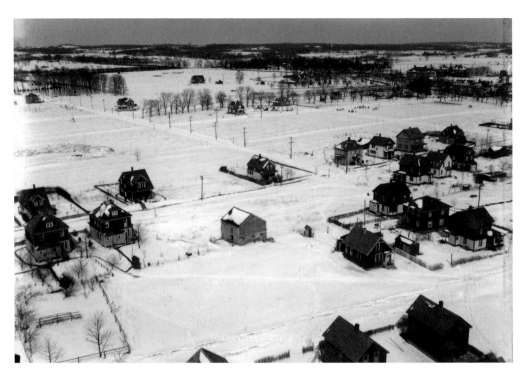

Lewis Avenue, 1916, seen from Drexel Water Tower. The intersection of Lewis and Grand is at center of the photo. The two school buildings are visible at upper right. *Photograph courtesy of the Historical Society of the Westburys.*

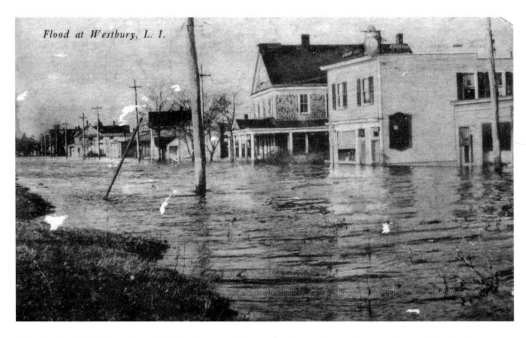

The flood of 1918 inundated Union Avenue (shown) and stopped trolley service on Maple Avenue for many weeks. *Photograph courtesy of the Historical Society of the Westburys.*

The earliest homes did not have garages, but by the late 1910s, freestanding garages were being constructed. Many of the older garages in Westbury are architecturally interesting. Some have spacious lofts that can be reached by stairs. One example is that of the former Ostermann house on Fulton Street off Post Avenue. Many older Westbury houses also featured open front porches, perfect for catching an evening breeze on a warm summer evening.

Though hundreds of homes had already been built by the late 1920s, there was still plenty of available land. In 1929, 88 lots in the Westbury Terrace area near the Westbury High School (on Jefferson, Cambridge, Rockland, Columbia and Princeton Streets) were offered for sale, as well as twenty-eight lots on Scally Place near the railroad station. At that time, the price of a new house ranged anywhere from $10,000 and up. In 1931, a developer named Charles M. Hiesinger bought 1,400 lots to build three hundred six- and seven- room houses on plots of about seventy-five by one hundred feet near Ellison Avenue.

In the days before sewer connections and other complications, moving buildings was relatively common. Bicycle shop owner Arthur Harris took his family on vacation to Maine in 1929, while his ten-year-old house was lifted off its foundation, carefully placed on planks and pulled by horses from Post Avenue near Maple to its current location on Wilson Avenue off Fulton Street. He wanted to raise his family away from the bustle of the center of the village. When the family returned to Westbury, they found their house in its new spot, with everything intact inside.

THE INCORPORATION OF WESTBURY

As Westbury continued to grow, change continued to occur. In 1924, Old Westbury was incorporated, allowing the wealthy residents to rely less upon the town of North Hempstead and develop their own government and services. In 1931, some of the residents in a strip of land between the turnpike and roughly present-day Asbury Avenue asked to be included within the limits of the village of Old Westbury, but their plea was rejected. With this no longer a possibility, their next effort was to register themselves as the incorporated village of Upper Westbury.

There was a backlash within the rest of Westbury (south of Asbury Avenue), whose residents felt the incorporation of Upper Westbury would hurt them as a community. A group of concerned citizens of both "lower" Westbury and the proposed Upper Westbury got signatures on a petition to form an incorporated village of Westbury that would include both Upper Westbury and the rest of Westbury into one entity. The group, led by Robert Renison and Justice of the Peace W.Y. Hollock, worked fast and quickly filed their petition at the county seat of Mineola in February 1932, literally minutes before the rival petition to incorporate Upper Westbury was filed. Because the petition to incorporate Westbury was processed first, the incorporated village came to exist as it is today, by a vote of two hundred to twenty-four. The official date of incorporation was April 20, 1932.

From Farms to Suburbs

National Boulevard and Jericho Turnpike, 1920s. *Photograph courtesy of the Historical Society of the Westburys.*

A History of Westbury, Long Island

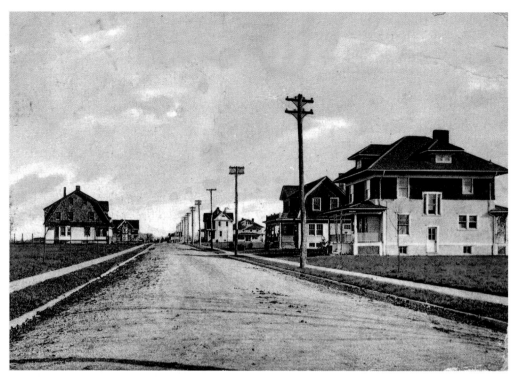

Victorian and colonial homes, Winthrop Avenue looking east, 1916. *Photograph courtesy of the Historical Society of the Westburys.*

Newly constructed home at Butler Street and Ellison Avenue, 1920s. *Photograph courtesy of the Historical Society of the Westburys.*

With incorporation, the village now could form a government and provide its own services to the community, and receive the recognition it deserved.

A Snapshot of Westbury in 1930

By 1930, Westbury was a busy and thriving village, with a population in the thousands and a wide variety of goods and services offered by people of numerous ethnic backgrounds. There were at least 160 people in Westbury who were employed directly for estates or families as cooks, maids, butlers, gardeners or general laborers. This does not include the dozens more who worked for contractors or builders who worked on various estates. There were at least 20 residents who worked with horses (as grooms, stable hands, polo experts or horseshoers). Many Westbury residents had green thumbs; there were more than 200 Westbury residents who were nurserymen, florists, seed salesmen, tree surgeons or gardeners. There were also still dozens of residents whose occupation was farming.

A survey of residents around the village in 1930 reveals the diversity of the population. At 45 Post Avenue lived a plumber named Joseph Strada (father of mayor Ernest Strada). Farther up Post were William Hickey, taxi chauffeur, and Joseph Kory, confectionary salesman. Also living on Post Avenue in 1930 were Tony Posillico, barber; Anthony Lagnese, barber; Harry Bair, haberdashery salesman; George Abbatiello, butcher; Louis Parillo, shoestore keeper; Francis Tatem, general feed sales; and Michael Knipfing, auto dealer. Many of the two-story buildings on Post Avenue still house apartments on their second floors.

Residing on Maple Avenue were Virgil McKenna, plumber; George, Adolph and Frank Froelich, farm laborers; Edward Neary, lawyer; Stephen Petrovits, doctor; Thomas Walsh, foreman for the Department of Highways; Thomas Guidera, contractor, and Robert Renison, florist. Living on Fulton Street were Carmen Lagnese, mason; William Rhind, electrician; and Norman Hollett, church musician. Living on Orchard Street were Nicholas Viscardi, laborer on a private estate; and Samuel Russo, shoemaker.

Living on Butler Street were Isadore Schach, stationery salesman; William Bostelmann, tax office clerk; Edward Staab, hardware merchant; Frank Staab, real estate broker; Richard Shaw, a gardener; Edward Owen, accountant; James Reardon, photo engraver; Christian Stevenson, schoolteacher; William Dolly, church sexton; and Thomas Callahan, horsefeed salesman. On Lewis Avenue were Clara Wolf, Red Cross secretary; Evelyn Smith, bookkeeper at the coal yard; James Reynolds, express company agent; and Jeremiah Reardon, gardener on an estate.

On Old County Road was Bernard Bergold, farmer. On Grand Boulevard were Pete Levi, dogman at a kennel; George Hesse, a retired butcher; Manuel DeRose, chauffeur; and Frank Hesse, mason. Living on Jericho Turnpike were Eugene Frawley, Ford salesman; Frank Benton, stockbroker; and Charles Johnson, estate superintendent.

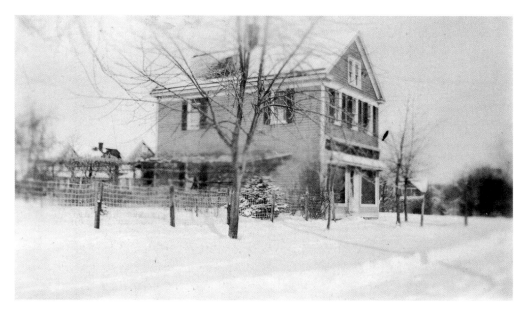

Building at the corner of Belmont Avenue and Fulton Street, circa 1920. It served as a small general store in the early twentieth century. *Photograph courtesy of the Historical Society of the Westburys.*

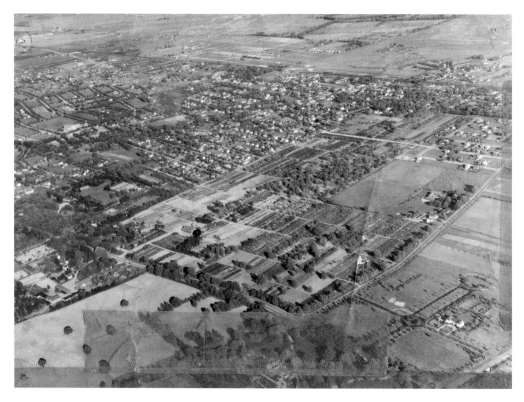

An aerial view of Westbury in 1930, looking south. Hicks Nurseries property in foreground and village to its left. *Photograph courtesy of the Historical Society of the Westburys.*

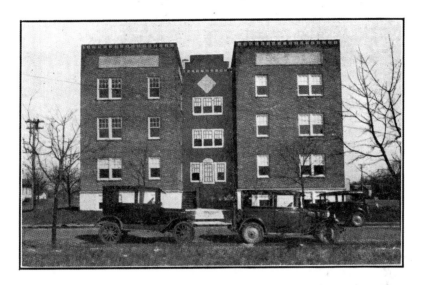

Advertisement for a new apartment building on Linden Avenue, 1929. *Photograph courtesy of the author.*

A History of Westbury, Long Island

Residing on Broadway were Emil Brussino, airplane mechanic and his father James Brussino, retired storekeeper; Henry Hartt, nursery salesman; and Russell Phillips, LIRR representative.

Out of all the heads of household living in Westbury in 1930, about 60 percent were born in the United States, and the majority of those were born in New York State. Besides New York, Westbury residents were most commonly from Pennsylvania, New Jersey and Connecticut. Of those born overseas, the most came from Ireland, England, Germany, Italy, Northern Ireland and Scotland.

The Durazzano Connection

A wave of settlers from Italy arrived during the early twentieth century to join the Irish and German settlers. Many of these families came from a single town in Italy—Durazzano. Their names—Buffalino, Abbatiello, Zaino, Ianucci, DeLucia and Posillico, to name a few—are still well known in Westbury today. Many of these Durazzano families settled in the section of Westbury across Post Avenue from St. Brigid's church, known as Breezy Hill for its slightly higher elevation than the rest of the village (and formerly the Thomas Taylor farm). They have remained a close-knit community, and even formed a Durazzano Society in 1929. The Italian presence in Westbury has

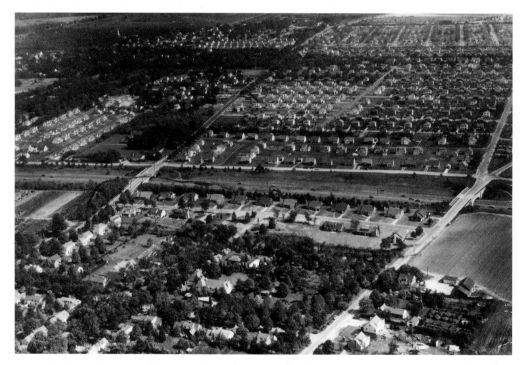

An aerial view of Carle Place and Westbury in 1950, showing Carle Road and Ellison Avenue. The Northern State Parkway runs left to right across the center. St. Brigid's spire is visible in the upper left of the photo. *Photograph courtesy of the Historical Society of the Westburys.*

remained strong to this day, and for years many Italian Americans have enjoyed friendly games of bocce at the recreation center. The mayor of Durazzano visited Westbury a few years ago, and then in 2003, a delegation from Westbury (including Mayor Strada) visited Durazzano, and the two communities officially became sister cities.

COMMUNITY SERVICES

The Robert Bacon Memorial Children's Library was a gift to Westbury from Martha Bacon, the widow of Colonel Robert Bacon, who had served as ambassador to France. When the library opened it doors in June 1924, it contained 2,513 books. Mrs. Bacon made the selections herself, with the assistance of a professional librarian from New York City. The first librarian, Jacqueline Overton, gave twenty-five years of service to the community.

The Neighborhood Association of Westbury, founded in 1916 by a group of concerned Westbury women, led to a Neighborhood House and the first welfare station in Westbury, with a registered nurse on duty. The Neighborhood House, on Winthrop Street, was the scene of many acts of charity and caring in the village. In 1922, the Meadow Brook Club held a charity polo match to benefit the Neighborhood House. The building was also the site of the early Mary L. Post Library. A subscription-based library then opened in the Community Center on Post Avenue in 1947, and in 1956, Westbury residents voted to convert the library into a public library. By 1963, it was clear that the small space in the Community Center was not sufficient, so a new Westbury Memorial Public Library building was constructed at its current location on Jefferson Street, and opened in 1966. A spacious addition was completed in 1995.

POST–WORLD WAR II DEVELOPMENT

Westbury sent 1,400 of its citizens—an extremely high proportion of the population—to war during World War II. The fire department alone sent thirty-five of their men to war. After the war, the development of large estates and former farms continued at a rapid pace. Returning veterans were looking to settle down. Long Island was quickly changing from a bastion of farming to a cluster of suburban communities. Westbury was now poised for unprecedented growth. The homes built in the ten- to fifteen-year period after World War II tended to be smaller than their predecessors, mainly ranch- or cape-style houses, including several hundred prototypes built by the Levitt company in Carle Place in 1946. The area south of Old Country Road began to see residential development. Originally known as Salisbury Plains, after the area where the British Westbury is located, this area was near the place where the Meadow Brook Club had been located.

In 1950, a thirty-six-acre plot of land formerly owned by Preston Davie (on Valentine Road) was sold and improved with homes in the $20,000 range. Also that year, fifty ranch-style homes were constructed near Old Country Road, east of Post Avenue. These

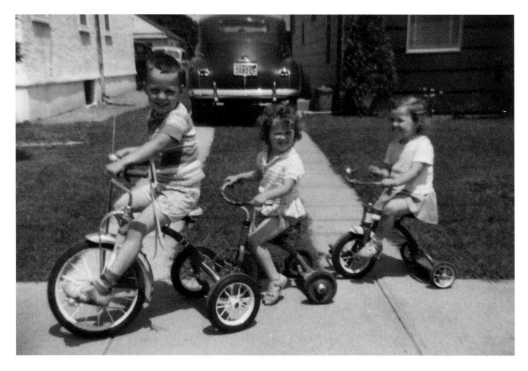
Three kids ride bicycles on Manhattan Avenue, 1956. *Photograph courtesy of the Prommersberger family.*

small, 4.5-room homes were on 50- by 100-foot plots, offered at just under $9,000 each. In 1952, a developer bought a plot of land along Jericho Turnpike measuring 800 by 1,600 feet. During the mid-1950s, a newly built 7.5-room home could be had for about $29,000. In 1957, land at Old Country Road and Westbury Road was developed for more than fifty split-level homes, which were offered in the range of $22,000–$24,000.

It was during the 1940s and 1950s that development also took off in Carle Place, which had been just a tiny settlement until that point. Westbury's neighbor was named after Silas Carle, whose ancestor Thomas Carle had first come to the area in the 1600s. When Carle built a large home in the early nineteenth century, people began to refer to the area as Carle's Place. There were a few scattered homes in the early days of the twentieth century, but the area was mainly populated after World War II.

In 1950, a plot of land fifty-five acres in size was acquired at Asbury Avenue, between Rushmore Avenue and Cherry Lane. The development was called Knollwood Terrace (today, there are adjacent streets in that area called Knollwood and Terrace).

Many of the Westbury homes in the area immediately south of the Northern State Parkway between Ellison Avenue and Plainfield Avenue were built after Hicks Nurseries sold off some of its land to developers. Some of the streets near Hicks (south of Asbury Avenue) are indicative of the land's not-too-distant past, with names such as Nursery

From Farms to Suburbs

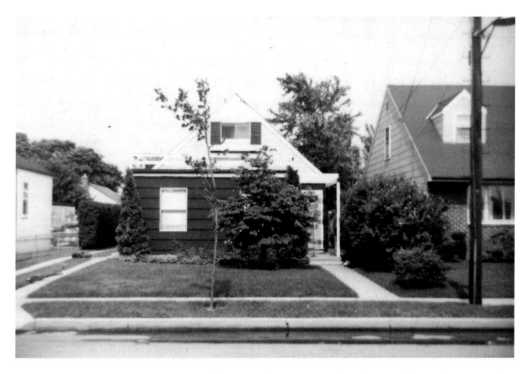

Eight Manhattan Avenue, 1961, typical of post–World War II Westbury homes. *Photograph courtesy of the Prommersberger family.*

Lane, Ivy Avenue, Walnut Street, Ash Street, Elm Street, Poplar Street, Pinoak Lane, Locust Street, Fir Street and Chestnut Street. Some of the streets between Jericho Turnpike and the Northern State Parkway also have botanical names; for example, there is Evergreen Drive, Rhododendron Drive and Hemlock Court. In 1956, developers bought a plot of land for an upscale development known at the time as Sherwood Gardens. The homes built on the land featured between 3 and 5 bedrooms and 2.5 baths and were priced between $30,000 and $34,000.

The land bounded by Ellison Avenue to the east, Carle Road to the west, the railroad tracks to the north and Old Country Road to the south was also developed during the years immediately following World War II. Street names in that section include Manhattan Avenue, Albany Avenue and Rockaway Avenue.

The area known as Poet's Corner (bounded by School Street to the west, Arlington Street to the east, the railroad tracks to the north and Old Country Road to the south) includes streets such as Tennyson, Dickens, Longfellow and Irving.

Westbury residents have always been active in the community, participating in a number of organizations. By 1965, the clubs and organizations in Westbury included the Henry Hicks Garden Club of the Westburys, the Women's Garden Club of Westbury, the Committee to Beautify Westbury, Westbury Neighborhood House, Westbury Community Council, Westbury Wheels Midget Football, Boy Scouts, Girl Scouts, Westbury Senior Citizens and Westbury Home Extension Service.

The population of Westbury Village was 4,525 in the year 1940. In 1950, it had reached 7,112. By 1960, it had risen to 14,757, but soon reached capacity, remaining between 14,000 and 15,000 after that.

Over the decades following the original construction of Westbury's homes, numerous improvements and expansions were made as families grew and houses aged. Many exterior porches were enclosed; spare bedrooms were converted to bathrooms; and outhouses were demolished as septic systems were installed in backyards; kitchens were expanded; sunrooms, greenhouses, dens and great rooms were added and dormers were added to attics and second floors. The trend continues today on an even grander scale, and several homes are more than double their original size. Sewers were finally installed in Westbury streets in the late 1970s, and houses that were sold after that had to be connected to the sewer system when purchased. In time, many of the larger double-sized lots that were fairly common in Westbury were split in two and new houses were built.

As time passed, fewer and fewer of the true old-timers remained, but they left behind their beautiful homes and gardens for a new generation of owners to enjoy.

A WESTBURY EDUCATION

On Long Island, as in the rest of the United States, schooling for children only became prevalent during the nineteenth century. The Westbury Quakers were ahead of their time. They founded a school in pre-Revolutionary days. In 1782, during the war, the school had to close when British troops occupied it. The school reopened in 1787. It was evidently one of the few schools in the area at the time; the children of Elias Hicks, who lived in Jericho, had to walk four miles to attend the Westbury Quaker School. In 1840, a second and more liberal (Hicksite) Friends school opened on Jericho Turnpike.

During the late eighteenth century, the Quakers also took up the task of making sure that the children of freed slaves were properly educated, paying for their tuition and supplies and offering adult education to their parents.

An influx of Catholic immigrants was one reason for the founding of a public (and non-Quaker) school. Isaac Hicks (founder of Hicks Nurseries) was a member of the original public school board of Westbury. The first school in Westbury south of Jericho Turnpike was built in 1840 on land rented from Edmund Powell for $4.85. The cost of the small structure was about $180. The first librarian of the school was given ten dollars to buy books. As enrollment grew, the school was soon replaced by a larger building (located in the vicinity of School Street), circa 1857. Originally a one-room school, the building was added onto twice during the next thirty years (once circa 1874 and again circa 1884). Also in 1857, a new Friends school was built near the Old Westbury pond. By the late nineteenth century, the Friends school had closed, so public school was the only option for Westbury children.

In about 1895, a two-story wood-shingled schoolhouse was constructed on a four-acre site in Westbury (about where the junior high school stands today), at a cost of eight thousand dollars. Together with the other, smaller school, these two facilities offered a child education through the eighth grade. In 1902, an addition was built at a cost of thirteen thousand dollars. Even then, the school was fast running out of space, with all the immigrants arriving in Westbury. A new school building (just off Post Avenue) was built in 1909 to accommodate grades kindergarten through third, making the 1857 building obsolete.

During the early 1920s, space was again an issue and the district was forced to rent a part of Hesse's Hotel (on Grand Boulevard). A four-year high school was finally constructed in 1924, marking the first time a Westbury child's education could be completed locally through the twelfth grade. Carle Place kids also attended Westbury

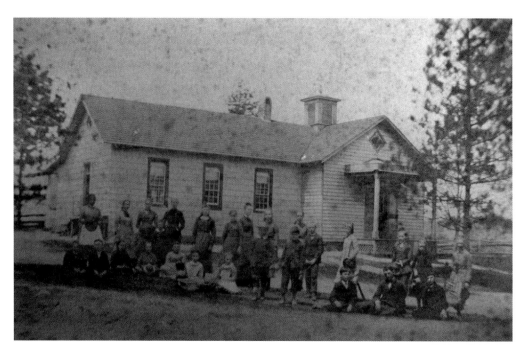

The Quaker School near Westbury Pond, circa 1880. Photo shows members of the Hicks, Willis, Titus, Bacon, Cocks and Willets families. *Photograph courtesy of the Historical Society of the Westburys.*

High until their own high school was built in the 1950s. Kids living in Breezy Hill and other parts of the village could be seen walking along Post Avenue to school every day.

Westbury's old wooden school building was demolished in about 1935 and a new middle school was built near the high school. The elementary schools on Drexel Avenue and Dryden Street date to 1952.

Meanwhile, St. Brigid's had operated a Catholic school on Post Avenue (across from the church) since 1919. By 1949, St. Brigid's was looking to build a larger school adjacent to the Hicks property, to replace the smaller Post Avenue facilities. The new 18-classroom school building was designed by William J. Boegel and was completed in 1955 at a cost of $900,000. Over a thousand students attended in the first year at the new location. An auditorium and more classrooms were soon added. An extension, designed by Boegel & Allodi Architects, was built a few years later to accommodate an increasing number of students; by the 1960s, there were sixteen hundred students enrolled at St. Brigid's.

The current Westbury High School (built in 1958) is at the northeast corner of Jericho Turnpike and Post Avenue/Post Road, and is actually located in what is technically Old Westbury, on thirty-four acres of land that had belonged to the Phipps family. A pedestrian bridge was built over Jericho Turnpike to ensure the safety of students. Once this new building was built, the old high school complex became the middle school.

The Westbury Friends began operating a nursery school in the year 1957. Tuition was twenty-five dollars per month for Friends. The school was also open to the general public.

A Westbury Education

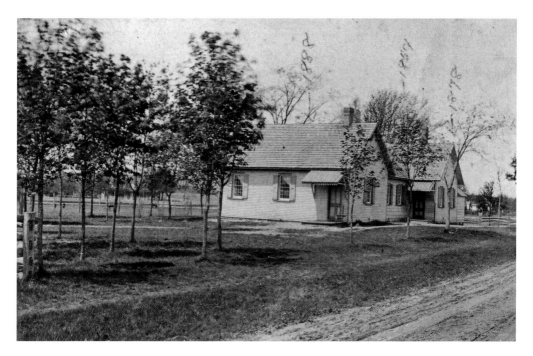

The first Westbury school south of Jericho Turnpike, late nineteenth century. *Photograph courtesy of the Historical Society of the Westburys.*

In its first year there were sixteen students enrolled. By 1964, the Friends School had a total enrollment of eighty-three pupils from nursery through second grade. Over the years, the Friends School expanded its capabilities and now offers classes from nursery to sixth grade. Also during the 1950s, the Red Robin School opened. Currently located on Jericho Turnpike, the school was a combination nursery school, kindergarten and day camp.

What Did They Learn?

The Quakers had excellent schools and learned extensively on a number of subjects. In 1830, Mary F. Willis (1817–1898) of Jericho, who later became the wife of Isaac Hicks, founder of Hicks Nurseries, studied from a book called *A Compend of History from the Earliest Times; Comprehending a General View of the Present State of the World, with Respect to Civilization, Religion, and Government; and a Brief Dissertation of the Importance of Historical Knowledge*. She read about ancient history, as well as "modern" history, the story of the founding of the United States.

At the time, history books were more subjective than they are today. They were quite likely to contain the author's opinion. For example, in Chapter 10 of Volume II, Miss Willis read, "The peasants in Poland, Sweden, Denmark and Russia, are the most ignorant people in Europe." She used a pencil to mark the paragraphs she had read and drew parentheses around the key names and phrases she needed to remember.

A History of Westbury, Long Island

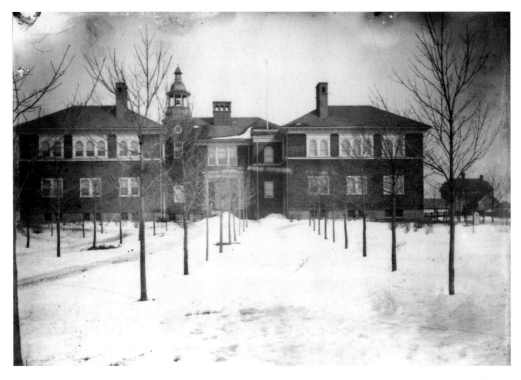

The wooden Post Avenue School, built 1895. *Photograph courtesy of the Historical Society of the Westburys.*

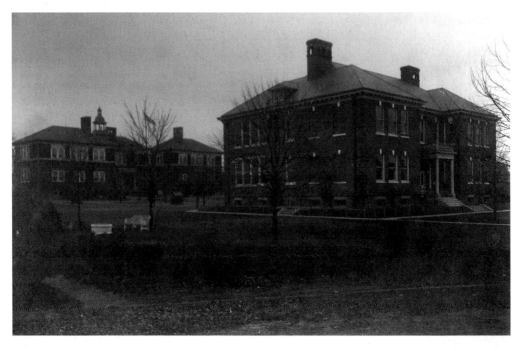

The new and old schools on Post Avenue co-existed for about twenty-five years before the old school was demolished. *Photograph courtesy of the Historical Society of the Westburys.*

Cover of a book used by Gilbert Hicks in 1855. *Photograph courtesy of the author.*

William Willets Cocks of Westbury (1861–1932), future United States congressman, read the stories, poems, grammar and dialogues in the *National Third Reader* (published 1868). He read the following passages in school in 1869, when he was eight years old.

> *Son: Father, my teacher heard me read a lesson about animal substances yesterday. He told me that an animal substance is any thing that ever formed a part of an animal.*
> *Father: Yes, my son, that is very true; and now I will tell you about two other kinds of things called vegetable and mineral substances.*
> *Son: What is a vegetable substance?*
> *Father: A vegetable substance is any thing that grows in trees, or bushes, or shrubs, or plants of any kind.*
> *Son: And what is a mineral substance, father?*
> *Father: A mineral substance, my son, is what comes from mines in the earth, such as coals, and metals, and stones of all kinds.*

He also read a poem called "Delay" which went like this:

> *Tomorrow, morrow, not today!*
> *'Tis thus the idle will ever say.*
> *Tomorrow I will strive anew,*
> *Tomorrow I will seek instruction,*
> *Tomorrow I will shun seduction,*
> *Tomorrow this and that will do.*

In 1855, young Gilbert Hicks (son of Isaac Hicks) studied from *A Primary Astronomy for Schools and Families*. In 1859, a teenaged Walter Hicks of Westbury learned about the sun, the moon and the planets from a book called, *A High School Astronomy: In Which the Descriptive, Physical, and Practical are Combined, with Special Reference to the Wants of Academies and Seminaries of Learning*.

Grace Hicks in 1874, followed by her brother Henry Hicks in 1876 (both children of Hicks Nursery proprietor Edward Hicks; Henry would grow up to run the business himself), read from *McGuffey's New First Eclectic Reader, for Young Learners* (an 1863 edition) when they were six years old. They learned the alphabet using some markedly different words than we do today. For example, "A" was for ax, "E" for elk, "F" for fan, "I" for ink, "J" for jug, "L" for lark, "T" for tub, "U" for urn, "V" for vine, "W" for wren, and "Y" for yoke.

Immigrants who came to Westbury from other countries did not lose their connections with their mother tongues. Parents encouraged their children to retain some of the old country. Marion Hedowich of Covert Avenue had a primer in Ukrainian (published 1928). She inscribed in the front: "Pity the maid, pity the cook, pity the one who steals the book."

In the 1930s and 1940s, Westbury school kids read a book called *The American Nation Yesterday and Today* and got to read briefly about the historic flight of "the Lone Scout of the Sky" (Lindbergh) that their parents may have witnessed firsthand in 1927. (Westbury was not mentioned; it only said that Lindbergh took off from Long Island.)

Trees, Flowers and Hicks Nurseries

Originally, Westbury south of Jericho Turnpike was part of the Hempstead Plains, a unique sand plain prairie that originally covered sixty thousand acres in central Nassau County. It was home to more than 250 species of plants and flowers and many types of animals. Some of the plants common to the plains were milkweed, wild indigo, sweet fern, violets, goldenrods and asters. Nineteenth-century farmers in Westbury used the land to graze their cows and sheep and Westbury was well known for its dairy farms. The Hempstead Plains were also found to be ideal for growing potatoes.

By the early twentieth century, the number of Westbury farms had decreased. The construction of large estates north of Jericho Turnpike led to the settlement of Westbury south of the turnpike. Transportation and infrastructure improvements meant that fresh produce could be brought from farms located further east in Suffolk County. The construction of the Roosevelt Field airstrip and the increasing population of Westbury, Mineola and Garden City and other communities caused a decline in the natural state of the Hempstead Plains. Today, only a few dozen precious acres are preserved off the Meadowbrook Parkway, just south of Westbury. However, it is likely that a trace of native prairie grass or shrub has survived here and there in an old Westbury backyard. Those stubborn weeds pulled up by Westbury homeowners could in fact be the last vestiges of the great plains of Long Island!

The once-grassy farmland of Westbury is now blessed with a gorgeous array of trees, shrubs, vines and flowering perennials. Older and more established trees, shrubs, vines and other plants create a lush and colorful appearance. The older trees are taller and have wider crowns that provide more shade than their younger counterparts. Many of the trees in the older sections of Westbury were planted between 1910 and 1940. The only section of Westbury that looks sparse compared to the past is Post Avenue, which used to be lined with lush shade trees.

These days, the best place in Westbury to see old trees is the large Quaker property on the corner of Jericho Turnpike and Post Avenue, which contains several buildings and a cemetery. With more than three hundred years of history, the Quaker property has some of the oldest and grandest trees in all of Westbury. Just a few feet behind the old Orthodox Meetinghouse, a massive tulip tree rises majestically skyward, its age

well over 100 years. Nearby is a large old linden tree. In fact, the property is populated with stately old trees of all types, including oak, maple, ash and spruce. A tree that fell recently was ring-counted at about 120 years old. Some years ago, all the trees on the property were mapped.

In 1876, Isaac Hicks (a Quaker and the founder of Hicks Nurseries) wrote the following about the importance of trees:

> *How does memory carry me back to those houses of Friends, nestled near a piece of woods, showing a love of the beautiful and useful combined; and those noble trees that were of the primeval forest, when the country was settled…There is something venerable and so conservative in these old trees around the meeting house that no lofty spire and no adornment of architecture can give. But all are not such. Too many meeting houses stand out in bold relief, with no sheltering tree to beautify the lawn…But these trees, young men. Will not you plant trees around your house of worship, and confer a lasting benefit to yourselves, meeting and the country?…the time may come when you may enjoy their beauty and comfort of shade, and future generations bless the hands that planted the shade trees around your meeting house.*

The Quaker property is not the only location in Westbury where old trees survived. One sixty-foot-high oak on Lewis Avenue that was felled due to a carpenter ant infestation in 2005 was about ninety-three years old. Trees of about one hundred years or more in age are scattered in many locations throughout the village. Several adorn the Westbury Manor property on Jericho Turnpike. Lining the south side of Jericho Turnpike, just west of Powells Lane, are several ancient trees. Another aged survivor stands on Nursery Lane off Asbury. One of the oldest trees outside the Quaker site is a linden tree on the property of the Post House apartments, near the old building at 342 Post.

Thanks to Hicks Nurseries (see below), Nurseryland (founded in the early 1970s) and other now-defunct businesses, the yards of many Westbury residences are adorned with old stock shrubs and plants such as climbing rose bushes, lilacs, rose of Sharon, clematis, ivy and various hedges. While most original homeowners are long gone, quite often their trees, shrubs and flowering bulbs have survived. Since the 1930s, Bartlett Tree Experts (Union Avenue) have worked to keep Westbury's trees healthy.

Westbury enjoys a wide array of birds attracted to the area by the abundant flowers, nuts, seeds and berries. Among the most commonly seen are blue jays, cardinals, sparrows, mourning doves, pigeons, robins, mockingbirds, woodpeckers, Canada geese, starlings and crows. Other rarer birds occasionally make appearances. Among the animals seen around Westbury are rabbits, raccoons, opossums and plenty of squirrels to enjoy the plentiful acorns. The squirrels have plenty of trees in which to make their nests. The rarely spotted opossums and raccoons come out at night and sometimes poke around garbage cans looking for a meal.

Hicks Nurseries

Hicks is the oldest family-owned business on Long Island and one of the oldest in the United States. The presence of and development of the nursery has played a role in shaping Westbury for more than 150 years.

Hicks was founded in 1853 by a Quaker farmer turned tree grower named Isaac Hicks, a member of the esteemed local family that had by that time already been in the United States for two centuries. Isaac's business (located at Jericho Turnpike, west of Post Avenue) got off to a quick start and his company, Isaac Hicks and Son, soon developed a reputation for its fine trees.

In September 1862, Isaac Hicks was showing fruit trees at the Queens County Agricultural Fair and won a ten-dollar cash prize and a diploma for having the best twenty varieties of apples. He worked hard, and the business grew as more people moved to Westbury and surrounding villages.

Isaac's son, Edward Hicks, became a professor at Polytechnic Institute in Brooklyn, commuting by railroad. He devised a method for moving and replanting large trees, a practice which the company began doing in about 1895. In turn, Edward's son Henry also became involved in the business. Hicks became quite renowned throughout Long Island and the entire Northeast. The company serviced numerous estates on Long Island and elsewhere, including those belonging to Morgan, Vanderbilt, Whitney and Phipps (now Old Westbury Gardens). They even planted trees at John D. Rockefeller's 4,180-acre estate, Kykuit, in Pocantico Hills, New York.

Indeed, the owners of large estates were more than pleased to receive trees that were well on their way to being fully grown. Most of these millionaires were the "new rich" and their estates built recently on former farmland. Their grounds lacked mature trees. As one advertisement proclaimed, "Don't wait for small trees to grow up—buy them grown up." Another ad proclaimed with amusement, "Cool Shade Trees This Summer—Not Little Sticks You Can Pat on the Head." By the turn of the twentieth century, large tree-moving projects had become pretty routine for Hicks. In about 1905, the company moved 175 evergreen trees ranging in size from fifteen feet to thirty-seven feet high to the estate of one Walter Oakman of Roslyn. Deliveries of trees were made by horse-drawn wagon until the nursery purchased its first truck in 1912.

By 1906, Hicks had tens of thousands of evergreen trees growing in its vast nursery, including the most affordable option, the pitch pine (one dollar for one hundred 8- to 12-inch trees). The company also employed twelve tree movers who could be dispatched far and wide with their special equipment. A 1908 advertisement for Hicks called the company "Isaac Hicks and Son, Nurserymen, Scientific Treemovers" and proclaimed the availability for delivery of large evergreen trees up to twenty-five feet high and twenty-five years old. A twenty-five-foot-high Norway maple, of which there were five hundred to choose from, cost anywhere from fifteen to thirty-five dollars. As of 1908, Hicks had one thousand large pine, spruce, fir, cedar and hemlock trees available. Evergreens, Hicks said in its advertisement, provided "beautiful

A History of Westbury, Long Island

There are many 100-year-old trees in Westbury. This tulip tree stands behind the Orthodox Meetinghouse just off Post Avenue. *Photograph courtesy of the author.*

Trees, Flowers and Hicks Nurseries

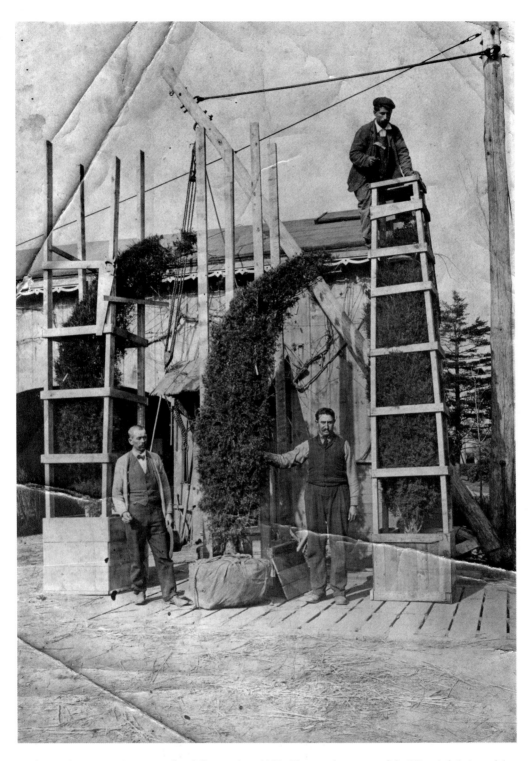

Hicks workers wrapping a tree for delivery, circa 1910. *Photograph courtesy of the Historical Society of the Westburys.*

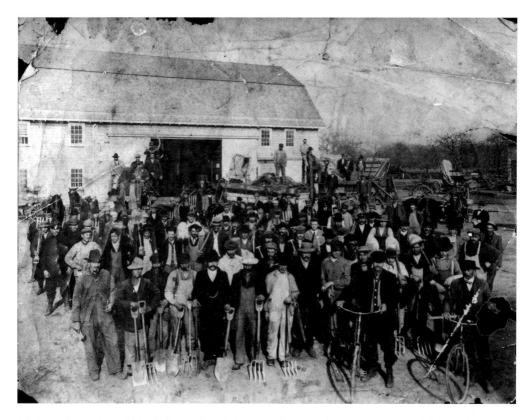

Hicks workers, circa 1910. Hicks employed dozens of local workers at the nursery. *Photograph courtesy of the Historical Society of the Westburys.*

surroundings for bleak, bare early Spring, and late Autumn and Winter week-ends." The company even offered its customers a special evergreen catalog from which to make their selections.

Hicks also had the ability to move truly gigantic trees (up to fifty feet in height and forty feet in spread) smaller distances, from one spot to another on an estate. This happened often because the ideal location to build a house did not always correspond with the location of existing large trees. Among his many other accomplishments, Henry Hicks experimented with varieties of plants that would thrive in Long Island's climate, and created a new variety of yew called the Hicks Yew.

Hicks advertised extensively in relevant magazines of the time, and their ad copy was quite well written. The Hicks ads had to compete with those of other nurseries in the Eastern United States who sold the same products. One 1910 ad proclaimed:

> *Tree for Sale—it is an oak 28 feet high, with a 13 foot spread. A splendid specimen that has been carefully trimmed and scientifically root-pruned. It can be moved right to your place and planted on your lawn and will grow right along as if nothing had happened… There are at least 75 other oaks quite as good as this in our Nursery, for you to select from.*

Another ad asked the question, "What is $40.00 a tree when it buys big, fine specimens like these? Think of having a shadeless, barren looking place today, and tomorrow wake up and find a tree 25 feet high sheltering one corner of your piazza or beautifying your grounds?"

The 1914 Hicks catalog was 116 pages long, and filled with hundreds of choice trees, vines, shrubs and flowering plants. An ad from that pre-potted-plant era proclaimed "Fine Big Clumps of Hardy Flowers for Planting Now." The growing popularity of the automobile increased the number of customers who went to Hicks in person and browsed the nursery stock. "Automobile trips to the Nurseries are in growing favor, owing to the splendid roads." Customers drove to Hicks, and loaded up their Model Ts with flowers, shrubs and evergreens of all types. Hicks told its potential customers to "Come anytime; you will enjoy the pungent odor of the evergreens; the crisp air, the good roads, and the fun of a day outside."

Hicks Nurseries encouraged a scientific approach to planting. They helped their customers decide what to plant when and which plants and trees would do well in their climate and soil type. They also encouraged their customers to do thoughtful landscaping of their properties, to provide windbreaks, screens and shade gardens. They encouraged the planting of trees in the fall, when the ground was still warm, but they also explained that trees could still be planted into December because the ground was still soft enough. Hicks cultivated and sold certain bushes—such as barberry, dogwood, cotoneaster, crabapple, mulberry, turquoise berry and viburnum—that could serve as food stations for winter birds. American trees and shrubs were not the only ones sold by Hicks. In 1923, Hicks was offering Japanese cypress, Nikko fir, Japanese hemlock and Japanese yew for sale. With improving transportation methods, Hicks was now able to deliver large trees even greater distances, including Boston, Massachusetts; Buffalo, New York; Cleveland, Ohio; Chicago, Illinois; Detroit, Michigan; Pittsburgh, Pennsylvania; St. Louis, Missouri; Baltimore, Maryland; Washington, D.C.; Newport, Rhode Island; Greenwich, Connecticut, and Bridgeport, Connecticut.

By 1928, Hicks was utilizing more than 230 acres of fertile Westbury land for growing their plants and trees, ranging in age from newly germinated annuals to decades-old

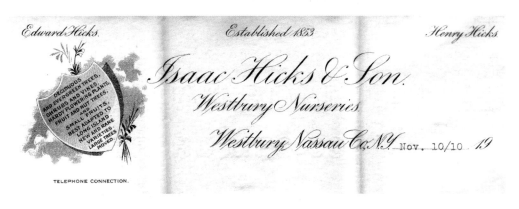

Hicks Nurseries letterhead, 1910. *Photograph courtesy of the author.*

A group of schoolchildren visits Hicks, 1972. *Photograph courtesy of Hicks family.*

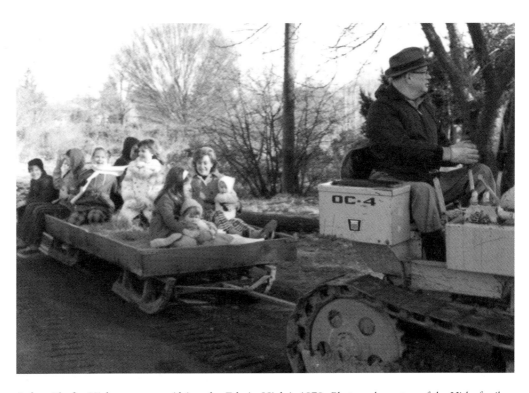

A fun ride for Hicks customers (driven by Edwin Hicks), 1970. *Photograph courtesy of the Hicks family.*

trees. Their ads in the late 1920s were appealing more to average homeowners, showing the different varieties of rare plants and shrubs that were available. For example, in the late 1920s, Hicks touted barberries, rhododendron, mountain laurel, Scotch heather, the Hicks yew, azaleas, Meyer's juniper, rock garden plants and beauty bush. "Modern life calls for change in gardens as in homes," an ad of the time proclaimed, "Move the old or overgrown plants to a new location, setting rare shrubs and plants from Hicks in their place." Hicks of the 1920s employed about three hundred people, many of them locals.

During the 1920s, Hicks also began to host an annual Fall Flower Show, held by the Westbury Horticultural Society. At the 1934 show, held in late September, the wealthy society wife Mrs. Herbert L. Pratt of Glen Cove was a big winner in the fruit and vegetable categories, winning numerous awards including best Dish of White Grapes, Two Bunches of Greenhouse Grapes, Dish of Five Apples, Dish of Five Pears, Dish of Twenty-five Lima Beans and Two Cucumbers. Mrs. Robert L. Bacon, of Old Westbury, won a prize for a centerpiece with flowers.

With the beginning of the Great Depression in 1929 and the subsequent decline of the great estates of the Gold Coast of Long Island, the need for large trees from Hicks declined. Instead, smaller homes were being built by the thousands during the 1920s, '30s, '40s and '50s. A 1938 home landscaping guide mentioned, "a simple Cape Cod cottage feels more at home with an unpretentious grouping of shrubs and a few dwarf evergreens." In 1944, tragedy struck when William Hicks, co-owner with his brother Edwin, died in World War II during the Battle of the Bulge.

By the 1960s, the company had shifted gears and looked almost completely to the retail market. That also meant a greater focus on shrubs and flowering plants that would fit in the scale of a typical fifty- by one hundred-foot plot of land. With less space required to grow plants as opposed to trees, the company sold off much of its land, and now has about 36 acres, still a great deal of land in today's high-priced market, but a fraction of the 245 acres of land it held at its peak. Though Hicks had less land, the size of the retail showroom has expanded dramatically since the 1950s. In 1971, retail greenhouses were constructed, in 1976 an addition built, and in 1981, the West House built. Further renovations in 1996 added more covered outdoor space.

Hicks is much more than just a nursery. It features children's shows, including a show starring the decades-old "Otto the Ghost" at Halloween, as well as a Christmas show. There are live animals, including goats, chickens and pigs during the fall and reindeer during the Christmas season. There is also roasted local corn in the fall. Just as every spring dawns in March, a landscaped flower show is held inside to pique interests. Of all of the Hicks's attractions, the show attracts perhaps the greatest following. The entire parking lot is filled, and cars are parked up and down Jericho Turnpike on show weekends.

With the untimely death of Alfred Hicks in 2004 at the age of sixty-four (his father Edwin Hicks had died in 1992), the business passed on to Alfred's children, Stephen and Karen. Before he died, Fred Hicks had the idea to build a friendly indoor café. This sunny new addition encourages shoppers to take their time, have a bite and enjoy the many items for sale in the gift barn.

From Horses to Airplanes

Horsing Around

Horses were not only a means of transportation in Westbury; they were used in several sporting activities. The Meadow Brook (sometimes "Meadowbrook") Hunt Club was very popular among the rich and famous during the late nineteenth and early twentieth centuries. It was first informally created in 1879 in Mineola, and officially founded in 1881. The club convened at various rural locations in Nassau County—especially where the hunting hounds and horses would be able to run free—but was headquartered in Westbury. In 1886, the Meadow Brook Hunt met at the home of future president Theodore Roosevelt (who was a member) in Oyster Bay. Roosevelt wrote in one of his books: "When I was a member of the Meadowbrook hunt, most of the meets were held within a dozen miles or so of the kennels: at Farmingdale, Woodbury, Wheatley, Locust Valley, Syosset, or near any one of twenty other queer, quaint, Long Island hamlets." Roosevelt explained the motivation for fox hunting: "The fox is hunted merely because there is no larger game to follow. As long as wolves, deer, or antelope remain in the land…no one would think of following the fox."

One member of the club was appointed as the MFH (Master of Fox Hounds) to lead the charge over several miles of terrain. The exciting sport was sometimes dangerous, as falls from galloping or jumping horses could cause injuries or even death. For example, in October 1892, thirty-one-year-old Charles Cottenet was killed after he fell from his horse while riding between Jericho and Westbury.

Hunting of actual foxes was not always practiced. Instead, the club often performed "drag hunts" in which the hounds followed the scent of anise seed (hounds have a strong attraction to this smell), which was laid out for them. The Meadow Brook Club preferred the drag hunt, partly due to the terrain of the area. It was difficult to coax the foxes out of the woods and into the open fields where they could be more successfully chased. As explained in an 1897 sporting book:

> *At least one-half of the Meadowbrook's members are men of business, who go daily to New York to their work. They get home by an afternoon train, and by dint of hurrying, gain two or three hours from the working-day, which they can spend on a horse's back.*

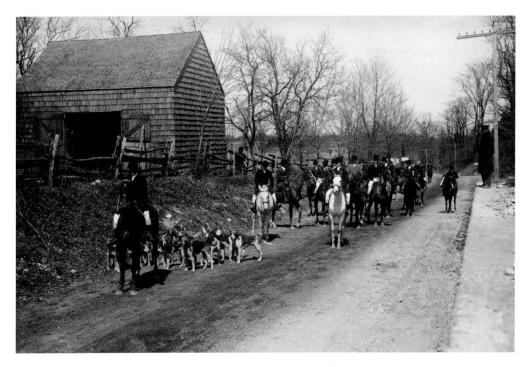

The Meadow Brook Hunt, 1912. *Photograph courtesy of the Library of Congress.*

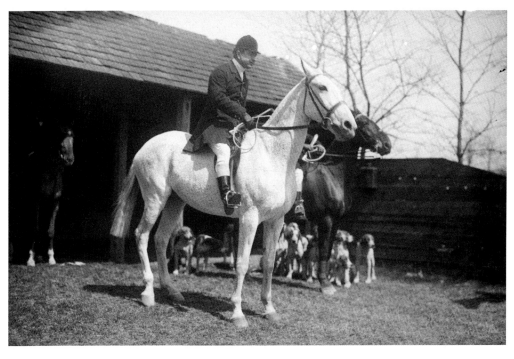

Samuel Willets, master of fox hounds for the Meadow Brook Hunt, early twentieth century. *Photograph courtesy of the Library of Congress.*

From Horses to Airplanes

Accordingly, when they get to the meet, at three o'clock or thereabouts, there is not time for an indefinite search after a fox, even if the country were favorable to such a quest. The Meadowbrook men want a sure run whenever they go out…they want it to end with certainty in time for dinner.

The drag hunt did not always work out. In one instance in Westbury, the dogs abandoned the anise trail when they came upon a real fox, and chased it instead. The first national women's golf tournament was held at the Meadow Brook in 1895. In 1899, a documentary film called "The Meadowbrook Hunt" was produced, showing hounds and huntsmen jumping over fences.

Westbury was often the location of the club's activities. On March 28, 1908, for example, the club met at Westbury Station and the hounds ran through farmland and north into the estates of Old Westbury. The thirty mounted hunters (both male and female) followed the hounds through the properties of Warner Baltazzi, Thomas Hitchcock, Charles Steele, Dudley Winthrop, E.D. Morgan and William C. Whitney. The Meadow Brook Hunt finally faded away in the 1940s, as development took hold of much of the open land on central Long Island.

The game of polo became popular on Long Island during the late nineteenth century and gained popularity as the wealthy moved into northern Nassau County. Growing out of the Meadow Brook Hunt Club during the 1880s was the Meadow Brook Polo Club, which became prominent in the early twentieth century. One of the founders was the local millionaire and polo player Thomas Hitchcock (1862–1941). It was one of the oldest and most prestigious clubs in the United States, and for many years, it was located in Westbury, south of Old Country Road and adjacent to the Roosevelt Raceway. The polo championships were held there often during the early twentieth century. In 1924, Edward, prince of Wales, visited the Meadow Brook Club to see the international games. One of the stars of the 1930s was Thomas Hitchcock Jr. (1900–1944). The Westbury team won the polo championship in 1937, 1938 and 1947. In 1954, the Meadow Brook Polo Club moved to Post Road in Old Westbury.

Because polo and horse riding (and later horse racing) were so popular in Westbury, local businesses continued to cater to horses long after other towns and villages had moved on. Even by the late 1920s, Westbury had many businesses that catered to horses. J. Bannister sold hay, straw, grain, feeds, baled shavings and peat moss. Henry Wilson ran Meadow Brook Vans—which provided horse transportation—on Winthrop Street. Harry Kopf, proprietor of the Westbury Transportation Company on Butler Street, provided horse transportation. F.A. Carle sold horse goods and dog supplies, including saddles, bridles, blankets, bits and riding crops. H.J. Sharp did horseshoeing and general blacksmithing on Belmont Avenue, or traveled to his clients' stables to shoe horses. Gustav Weber was a saddle and harness maker on Post Avenue. Joseph Ellison, the blacksmith, made horseshoes at his shop on Post Avenue. Barley's Pharmacy sold International Body Wash products made to keep horses' muscles and ligaments in good condition after racing, hunting and exercising.

Polo match at the Meadow Brook field, 1913. *Photograph courtesy of the Library of Congress.*

From Horses to Airplanes

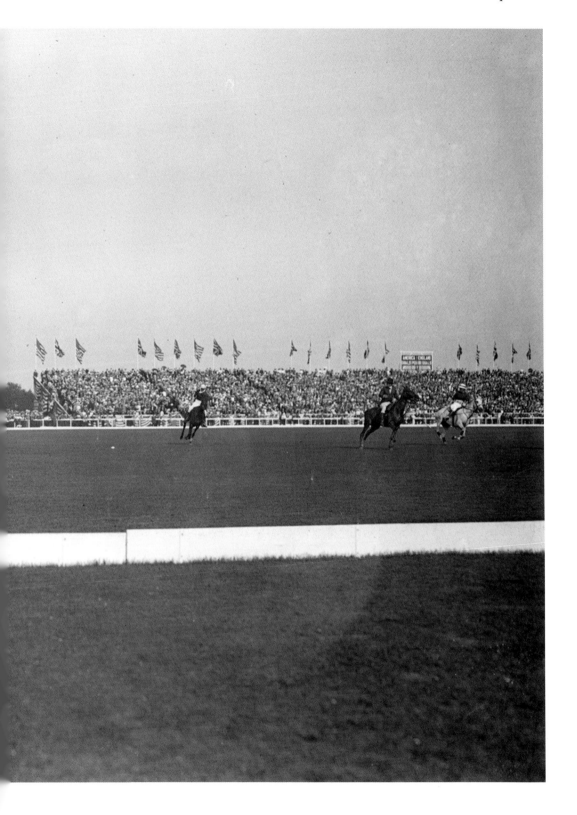

A History of Westbury, Long Island

Bicycles

Invented in 1871, the bicycle was a new and popular way to travel during the late nineteenth century. It appealed to the public both as a new pastime and as a method of transportation.

Arthur Harris, who died in 1953, is the Westbury name most associated with bicycles. He came to Westbury from New York City in about 1911, purchasing M.J. Knipfing's bicycle business, and opened a bicycle and motorcycle shop on Post Avenue near Maple Avenue, about where the Rite Aid drugstore is now located. He was a dedicated bicycle rider and enthusiast. Harris also sold kerosene from his business and eventually branched out to automobile repairs, moving to the northeast corner of Post and Maple. Through it all, bicycles remained popular. During World War II, servicemen stationed at Roosevelt Field went to the Harris Shop to rent bicycles for twenty-five cents a day.

Automobiles

The invention of the automobile in the late nineteenth century did not immediately change life for everyone. In fact, it took twenty years and Henry Ford's mass production before automobiles caught on. For example, in 1900, there were 4,192 automobiles sold in the United States. In 1905, the number had increased to 24,250 (with a total of 78,000 cars registered by then), and by the year 1910, 181,000 cars were sold in America. Still, by 1910, relatively few people owned automobiles. In small towns such as Westbury, it was simple enough to travel by foot, horse or bicycle. Post Avenue, central to most of the residential areas of Westbury, offered nearly everything a resident might need.

Yet as early as November 1901, a special committee appointed by the Nassau County Supervisors wrote a report examining the issue of speeding automobiles on Nassau roadways. William W. Cocks and Benjamin D. Hicks of Westbury were members of the committee.

Evidently, speed continued to be an issue even after the committee's report was issued. On December 3, 1902, W.L. Stow of Westbury was arrested on Jericho Turnpike and charged with speeding. He was fined twenty dollars, a princely sum in those days. In 1908, work was completed on a nine-mile segment of the Long Island Motor Parkway, a toll roadway dreamed up by the wealthy William K. Vanderbilt. It ran from Westbury, south of Old Country Road, to Bethpage. (Though Vanderbilt envisioned the Parkway on a much grander scale, by the 1930s, both the idea and the existing roadway were abandoned.)

It was between 1915 and 1920 when the automobile really began to make an impact in most suburban areas; in 1920, nearly two million automobiles were sold and by then over nine million were registered. The affordable price of Henry Ford's Model T (it could be had for about $850 when first introduced in 1908, but the price dropped to about $290 by 1925), and of the later Model A made owning a car more desirable.

By the 1930s, automobiles were a huge part of Westbury life. All around the village there was an array of businesses revolving around cars. On Post Avenue, there was

From Horses to Airplanes

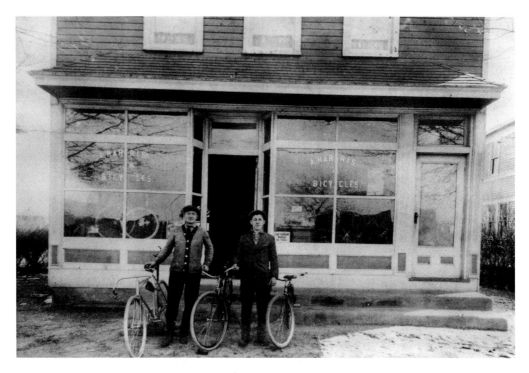

The Harris bicycle shop on Post Avenue, circa 1910s/1920s. *Photograph courtesy of the Historical Society of the Westburys.*

During World War II, servicemen stationed nearby could rent bicycles at the Harris shop for twenty-five cents a day. *Photograph courtesy of the Historical Society of the Westburys.*

Automobile traffic on Jericho Turnpike was light during the 1920s. *Photograph courtesy of the Historical Society of the Westburys.*

From Horses to Airplanes

Michael J. Knipfing's Ford and Lincoln dealership and garage at Post and Belmont (where an office building and parking lot are today). Knipfing, who was born in Germany and came to the United States as a child, also made and sold tractors and dump carts for use on golf courses, polo fields and private estates. By 1930, Knipfing's sons, Francis and William, were mechanics at his garage.

There was the Arthur Harris garage on the corner of Post and Maple. Also on Post was Albert Schwicker's (brother of the general store proprietor) Chrysler dealership. At Maple and Union was J.J. Dowling's repair shop. (He later opened a Chrysler-Plymouth shop on Post between Lewis and Wilson.) On Butler Street were Baker Auto Electric Service and also the Westbury Transportation Company, run by Harry Kopf, offering moving vans and trucks. Chapman Brothers sold Chevrolets from their shop on Butler Street. At Old Country Road and Post Avenue was the Fleet Filling Station, offering Goodyear tires. Wheatley Taxi operated on Post Avenue. The Post Avenue Garage was operated by Ferdinand Navrot on Post Avenue and provided auto repairs, tires, oil and accessories. The Triangle Service Station, run by Nicola Piscitelli, was located at Union Avenue and Seaman Court.

While the automobiles of the late 1920s and early 1930s were faster and more comfortable than their predecessors, the infrastructure still did not exist to transport people quickly back and forth from Queens, Manhattan and other points to Nassau County on a regular and large-scale basis. Jericho Turnpike and Old Country Road were still the two main ways to head east or west from Westbury. While they were considered fine roads for their time, they were not built for high-speed travel.

Everything was about to change. The Northern State Parkway, a continuation of Queens's Grand Central Parkway, began construction in 1931. Designed by the famed urban planner Robert Moses, the landscaped roadway was for noncommercial traffic only. By 1934, the parkway had been constructed as far east as Exit 31 (Carle Place). The process of land acquisition was not going as smoothly as it could have. Wealthy property owners objected to the parkway cutting through their neighborhoods. In the end, the Northern State Parkway had to take on an "Objector's Bend," a two-mile detour in the roadway that took it south through Westbury, rather than Old Westbury or points north. Between 1936 and 1938, the parkway was extended to Exit 33 in Westbury. Several Westbury buildings were moved to make room for the parkway, including the Ellison blacksmith shop (moved to Post Avenue), and the home of C.C. Boyd, the first mayor of Westbury.

Other Moses Parkways were built around the same time. The Meadowbrook State Parkway was begun in 1932, and eventually connected Jones Beach and other points south with Carle Place. The Wantagh State Parkway was also built in the 1930s, and connected with the Northern State Parkway in Westbury in 1938.

Due to the existence of these new highways, Westbury was now poised to grow even more rapidly, as suddenly New York City seemed much closer. Development slowed once America entered World War II in late 1941, but after the war ended in 1945, everything was accelerated once again. Cars, which had not been produced since 1942, were once again manufactured. Both returning veterans and homefront patriots eagerly purchased the 1946 and 1947 models. With the Great Depression finally over, people on

From Horses to Airplanes

Roosevelt Field as it appeared in 1958. Mall shopping depended on automobiles. *Photograph courtesy of the Prommersberger family.*

Long Island were earning and spending money. Furthermore, the new cars of the late 1940s were a far cry from the models of the early 1930s. They were bigger, faster and more comfortable.

With the coming of the Northern State Parkway and Long Island Expressway, something strange began to happen. Residents of New York City, who had previously had little reason to visit Long Island other than recreation, were coming to shop. The development of Old Country Road during the 1950s and 1960s (following the closure of the Roosevelt Air Field) was the start.

The newest development in shopping was strictly a product of the automobile's popularity. The Roosevelt Field Mall, first opened in 1956 (with parking for eleven thousand cars), was the harbinger of things to come. At first an open-air or strip mall, it created a one-stop shopping experience that drew eager shoppers from miles away. It is hard to say exactly how much of a dent Roosevelt Field made in the business of downtown Westbury. It is safe to say that with the advent of the mall, people began to shop more extensively in towns other than their own.

Though Roosevelt Field became an indoor mall, the strip mall continued to be increasingly popular. Consisting of a row of adjoining stores with a conjoined parking lot, strip malls were built by the hundreds throughout Long Island, along roads such as Jericho Turnpike, Old Country Road and Hempstead Turnpike. As the 1950s turned into the 1960s, shopping in Westbury became synonymous with driving.

Another product of the automobile was the supermarket. America's so-called "first" modern supermarket was King Kullen, which first opened in 1930 in Hollis (Queens) and soon spread to many locations on Long Island, along with Waldbaum's, which by 1960 had thirty-five stores in Nassau County, Queens and Brooklyn. Driving to the supermarket was quickly becoming the preferred alternative to walking to the corner grocery or butcher.

Infrastructure throughout New York City and its many suburbs has suffered the same fate over the years. Originally designed for foot traffic or horse and carriage traffic, the oldest roads in the area simply could not handle the volume of traffic that automobiles presented. Those that were actually designed for automobiles were designed for a 1930s volume of traffic, much lower than today's volume.

Traffic in Westbury has certainly become heavier over the years. While Post Avenue on an early Sunday morning is nearly deserted, at key times on weekdays—especially during rush hour—there is a solid line of cars from Jericho Turnpike to Old Country Road. Commuters exiting and entering the Northern State Parkway, Wantagh State Parkway and Meadowbrook State Parkway combine with those leaving the Westbury train station parking lots and create a busy scenario.

Similarly, Old Country Road is usually jammed on weekends with the cars of shoppers from all over Nassau County, and even Queens, Brooklyn and Suffolk County. Westbury drivers make up only a fraction of the traffic.

Alleviating these modern-day traffic logjams is not so simple. In the old days, widening a road was simpler to accomplish because it affected fewer homes and businesses. In Queens for example, Queens Boulevard had to be widened around the turn of the twentieth century to accommodate automobile traffic. Only a couple of buildings had to be moved. Attempting a similar project today would be impossible.

In 1997, congestion on the Northern State forced the State Department of Transportation to add an extra lane to the Parkway in each direction between the Meadowbrook and Wantagh Parkways, replacing the original stone Moses overpasses in Westbury with facsimiles.

The Vanderbilt Cup

Some of the biggest events in automotive history took place in Westbury, beginning back when the main form of traffic on Westbury roads was still horse and carriage.

The automobile was still a very new contraption when in 1903, racing trials were held on Long Island for the Gordon Bennett Cup Race in Ireland. The racecourse ran a length of six miles from Westbury south to Merrick.

The first international road race was held on Long Island in 1904. The event was called the Vanderbilt Cup Race, and its start/finish line was in Westbury. The race's primary benefactor, William K. Vanderbilt, was a local millionaire and racing enthusiast. He donated the prize, a beautiful, engraved sterling silver cup. In 1901, Vanderbilt himself had briefly held a speed record when he drove his Mercedes 5 miles in a time

of about seven minutes (a little more than 40 miles per hour). The total length of the racecourse was about 285 miles (a total of ten laps around the course). The 1904 race program explained:

> *That Long Island is honored by its selection as the course for the first international road race goes without saying. That some of its less progressive citizens have objected to its use for that purpose shows the same lack of public spirit that retards its growth in other directions. What Long Island most needs to hasten its development is adequate transportation facilities and that class of advertising which will bring the "stranger within its gates." The automobile, in a general way, fills both of these needs and the Cup Race, in particular, will be the means of introducing thousands to its fine roads, pure air and splendid properties.*

The racecourse was a loop that began and ended at Westbury, as described in the race program:

> *Beginning at the starting point, located on the famous Jericho Road near Westbury, the actual starting line being at the centre of Stand A, the road stretches toward the east in a comparatively straight line, over a somewhat rolling country, until it reaches the old Quaker town of Jericho, where the first turn is located…Leaving Jericho, there is a fine, almost straight-away run to Hicksville…the finest stretch of road in the entire course is before the contestant, being a practically straight-away and splendidly surfaced road direct to the Bethpage turn…From the Bethpage turn there is a straight run to the Hempstead control.*

From Hempstead, the racers were to proceed over the county border into Queens, through Floral Park, through Mineola, and then back to finish line in Westbury along the Jericho Turnpike. The race started at 6:00 a.m., so spectators had arrived early in the morning. Some adventurous spectators ventured along the racecourse, and even crossed the road between passing racecars. The winner of the 1904 race was George Heath, an American-born British citizen living in France. He was driving car number 7, a French-made Panhard & Levassor that operated on four cylinders and had a seventy-five-horsepower engine. Heath finished the course in a time of five hours, twenty-six minutes and forty-five seconds, averaging a little more than fifty-two miles per hour over the entire race. Second place went to A. Clement Jr., driving a ninety-horsepower Clement Bayard, less than two minutes behind the leader's pace.

The race should have continued, allowing all the other eligible cars to finish, but after the second car came across the finish line, the crowd began to leave, blocking the racecourse and ignoring the pleas of William Vanderbilt to clear the way. The race had to be stopped. It was a success overall, except for a racer who was injured and a mechanic who was killed.

In the 1905 race (the grandstand was not in Westbury this time), the average speed of the winner was more than sixty miles per hour. George Heath, the 1904 winner, came in second place.

A History of Westbury, Long Island

The racecourse for the 1904 Vanderbilt Cup. The start/finish line was on Jericho Turnpike in Westbury. *Photograph courtesy of the Historical Society of the Westburys.*

From Horses to Airplanes

A History of Westbury, Long Island

The 1904 Vanderbilt Cup Race winner, George Heath, and his car. *Photograph courtesy of the Historical Society of the Westburys.*

For the 1906 race, the grandstand was once again at Westbury. It was made of wood and was 750 feet in length. Eight carloads of oil were used to treat the road surfaces before the race. An article in the 1906 program of the Vanderbilt Cup proclaimed, "a new era for Long Island was ushered in" that October day of the first race in 1904:

> *Before noon on that eventful Saturday the eyes of the whole world were centered on our narrow strip of land. In no portion of the United States have land values and general prosperity been affected as they have here in Nassau County, Long Island. No writer refers to Long Island without a direct reference to the Vanderbilt Cup race, along with the stereotypes arguments of "good roads—good air—good water." We have all of these. In addition, we have a farming population who are rapidly joining the ever-growing ranks of the automobilist.*

The cup race was held at various locations on Long Island through 1911, and then elsewhere in the United States until 1916. In 1936, a new, closed racetrack was planned in Westbury, on the site of Roosevelt Field 1, the one from which Lindbergh had taken off. Present at the dedication ceremony on June 12, 1936, was Kermit Roosevelt, son of Theodore Roosevelt and brother of Quentin Roosevelt (who had died in World War I), after whom Roosevelt Field had been named. An American Airlines plane landed on the field as part of the celebration; several pilots who had used Field 1 were in attendance.

Roosevelt Raceway marked the return of the Vanderbilt Cup (now called the George Vanderbilt Cup) to Long Island. The course was built in just eighty-three days, and the track was tested in September 1936, when thousands of cars, both racers and leisure drivers, ran the course for the first time. Though originally set for four hundred miles, the race was cut to three hundred miles in length because of the difficulty of the course.

Cover of the Vanderbilt Cup Race program, 1906. *Photograph courtesy of the Historical Society of the Westburys.*

The course included a 3,775-foot-long straightaway that allowed cars to reach speeds upwards of 150 miles per hour.

More than forty racers took part in the October 12, 1936 contest, which started at 11:00 a.m. The field included such well-known racers of the time as Wild Bill Cummings and Billy Winn. A crowd of more than fifty thousand people witnessed the race from the multi-tiered grandstand. The illustrious Board of Judges for the race included Mayor Fiorello LaGuardia of New York City, Edsel Ford, Kermit Roosevelt and Harvey Firestone.

The winner of the 1936 contest was Tazio Nuvolari, a forty-year-old Italian driving an Alfa Romeo for a time of four hours, thirty-two minutes and forty-four seconds, at an average speed of nearly sixty-six miles per hour. Nuvolari received an engraved cup as well as a $20,000 prize. A Frenchman finished second and won $10,000. The leading American, Mauri Rose, finished in sixth place and won $2,200.

After the 1936 race, the course was altered to increase the average speed. It evidently worked, because a German racer trying out the course in June 1937 hit a record 158 miles per hour on the course. A crowd of seventy-five thousand people witnessed the 1937 George Vanderbilt Cup at Westbury. The race, originally set for July 3, had to be postponed due to heavy rain and took place a couple of days later. The *New York Times* hailed the race beforehand as the "greatest auto race in history," but Americans were very disappointed when the German racer Bernd Rosemeyer won the contest with an average speed of eighty-two miles per hour.

In August 1939, a three-hundred-lap midget car race (the first national championship) was held at Roosevelt Raceway, but that pretty much marked the end of the Raceway's automotive history for a while. The next Vanderbilt cup race at Roosevelt Raceway would not be held until 1960, when it was sponsored by another member of the Vanderbilt family, Cornelius Vanderbilt IV. An American named Harry Carter finally won.

Roosevelt Raceway Reborn

Auto racing was not the only racing sport that was a part of Westbury history. As the 1930s drew to a close, a Freeport attorney named George Morton Levy (1889–1977) had the idea to build a nighttime harness horse racing track (the first in New York State) on the site of the old auto racing track. The stands at the new half-mile trotting track would have a capacity of ten thousand and there would be one hundred betting windows.

The first race was held in early September 1940 under the floodlights that were installed. Special Long Island Rail Road trains were run for the event. A total of 4,584 people attended and paid either $1.00 to get into the grandstand or $2.00 to enter the clubhouse. A total of nearly $41,000.00 in bets was placed. Attending the races was a social event, and many members of society were there to meet their friends and acquaintances as much as to watch the races.

Advertisements touted the nightly races. In 1940, there were twenty-seven nights of racing, with a total of 75,000 in attendance and $1.2 million in bets. By 1945 there were races on ninety-four nights, with a yearly attendance of 845,000 and $28 million in

From Horses to Airplanes

Cover of the Vanderbilt Cup Program, Roosevelt Raceway, 1936. *Photograph courtesy of the Historical Society of the Westburys.*

bets. That same year, the raceway welcomed its one millionth fan. As the years passed, more and more patrons flocked to the races. So popular was the raceway that a massive expansion was planned in 1956.

In 1957, the new complex opened, with seating capacity of sixty thousand and an extensive parking lot. In 1959, attendance at the raceway was 2.5 million. On November 30, 1959, a new single-day harness racing betting record of $2,692,585.00 was set at Roosevelt Raceway. The record was broken on August 20, 1960, when betting at the raceway reached $2,730,113.00. Single-day attendance records were also set; in 1957 it reached 50,336 and in 1960 attendance peaked at 54,861. New records were also set for horse racing winnings. In September 1964, an all-time high twin double payment of $172,726.00 was paid to Robert Froner of Brooklyn. In 1966 a new 336-foot long electronic tote board was installed at the Raceway, state-of-the-art for its time. In 1967, the raceway welcomed its fifty millionth fan.

From Horses to Airplanes

Harness racing at Roosevelt Raceway was very popular from the 1940s through the 1960s. *Photograph courtesy of the Historical Society of the Westburys.*

The Roosevelt Raceway was an immensely important part of Westbury life. Residents flocked to the track to see the exciting races. Countless Westbury residents worked at the track, everyone from teenagers working their first jobs to adults working a second job for extra income. For many, it was easy enough to walk there. Drivers, trainers and jockeys frequented Westbury taverns and eateries. The effect was contagious; the proprietors of the Greentree Inn (Masciello) and of the Post Tavern (Barki) both owned racehorses.

Horse racing was in the air, so to speak. Mayor Ernest Strada, who worked at the Raceway for many years, recalls experiencing the races from his home:

> *When the evening was still, and the atmospheric conditions were appropriate, you could hear the roar of the crowd as the horses ran the stretch approaching the finish line. You knew when the race ended because the roar would just shut right down…you could be sitting in your backyard on a summer evening and you could hear the announcer at times if the wind drifted right.*

After peaking in popularity during the 1950s and 1960s, the raceway declined in popularity through the 1970s and 1980s. Though the faithful still went regularly, gone were the packed houses, and with it the profitability. Attendance reached 3 million several times after the peak year of 1964, but stayed under 3 million after 1971, and under 2 million after 1976, with average attendance falling to around 10,000, from its peak of 26,000 in 1964. Finally, it became more cost-effective to sell the property to developers.

In July 1988, the Roosevelt Raceway closed. The raceway was used for weekend flea markets until 1995. The abandoned stands stood for twelve years, ghosts of a once glorious past, before they were demolished in 2000 to make way for stores and a four-screen movie theater, called the AMC Loews Roosevelt Raceway.

The Rail Connection

The Long Island Rail Road was first chartered in 1834 and began operating in 1836, during the very infancy of the railroad industry. Among the ambitious plans was a line of tracks to extend to Greenport on the North Fork of Long Island (present-day Suffolk County). The first trains to pass through Westbury began service in 1837 and served the terminal station of Hicksville. There were two trains daily. Service was extended east to Central Islip by 1841, and to Greenport on the North Fork of Long Island by 1844. Though the Mineola/Carle Place area had a station as early as 1844, Westbury did not have its own station until about 1883. Still, passengers could buy tickets at Kelsey's general store at the junction of Post Avenue and the tracks (which served as a depot and also housed the post office), and wait there for their train. By 1877, there were seven trains daily eastbound and eight trains daily westbound. The one-way fare to Jamaica in 1877 was fifty-five cents, while the round trip was one dollar. In 1895, a mail train heading to Long Island City from Greenport collided with a farm wagon near Westbury. The only injury was a broken arm.

From Horses to Airplanes

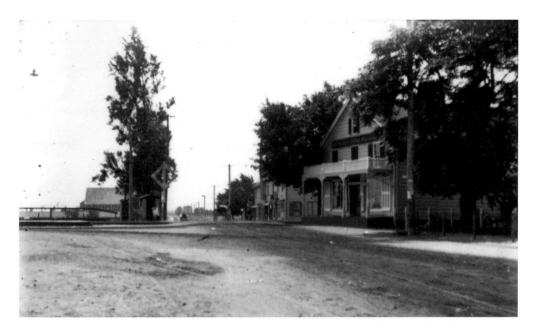

The dangerous Post Avenue rail crossing, as it appeared before the grade crossing was eliminated in 1914. *Photograph courtesy of the Historical Society of the Westburys.*

Out of many thousands of rail crossings around the country, the crossing at Westbury's Post Avenue had a quite dubious distinction. The tracks at Westbury were the site of the first documented crash of a train into an automobile in the entire United States. The fateful event happened at the end of October 1901, when the famous French automobile racer Henri Fournier was returning from the nearby Meadow Brook Clubhouse, where he had spent some time with the wealthy William K. Vanderbilt Jr. (who would a few years later start the Vanderbilt Cup race).

Fournier's automobile was filled with five other passengers, including a newspaperman from the *New York Journal* and a newspaperman from the *New York Herald*. As they approached the tracks, the occupants of the crowded car did not hear the bell that warned of an oncoming train. Because of buildings in proximity to the tracks, Fournier and his passengers also had a limited view of the tracks. As their car came to the crossing at about six miles per hour, an oncoming train smashed into it, sending the passengers flying into the air and destroying the nine-thousand-dollar car. All six occupants of the car were injured. The superintendent of the Long Island Rail Road was on the scene soon after the accident to examine the situation.

The crash did not seem to affect Fournier too badly; his only complaint was a sprained left foot. Just a little over two weeks later, in November 1901, Henri Fournier was able to drive a French-made Mors automobile a distance of one mile in about fifty-two seconds at Coney Island in Brooklyn, for a new speed record. Meanwhile, two of Fournier's passengers sued the Long Island Rail Road for ten thousand dollars in damages, but their suit was dismissed in 1903.

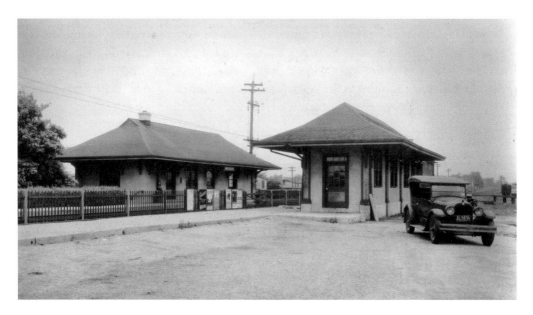

Westbury railroad station, 1920s. *Photograph courtesy of the Historical Society of the Westburys.*

Another Westbury train-car crash happened just a few years later, in May 1906. This time, the accident was fatal to the occupants of the automobile, a chauffeur and valet for Robert J. Collier of Wheatley Hills. The car, which was traveling about forty miles per hour, was smashed to pieces as it hit the train. The five-car train was evidently obstructed from view of the speeding automobile by Kelsey's general store. The need for a flagman at the Westbury crossing was discussed after these accidents, and the State Railroad Commission asked that the at-grade crossing be eliminated.

In June 1911, two more deaths occurred at the crossing as another car was struck by a train. This time, the driver survived, but his two passengers did not. The driver apparently ignored the signal of the flagman, who waved at him to stop. The president of the Long Island Rail Road called the accident a suicide attempt. The Westbury crossing had become known as Death Crossing because of all the accidents.

A meeting with the Long Island Rail Road and members of the Westbury community was held in the Luessen's Hotel, and, thankfully for area residents, elimination of the grade crossing was finally implemented in 1914. The train tracks were elevated and the Post Avenue was routed under a bridge.

The number of commuters from Westbury to New York City has increased steadily over the years. In 1910, there were, on average, thirty-two commuters daily from Westbury. This number soon increased due to the opening of Penn Station in Manhattan. Before 1910, commuters had to get off in Long Island City and find other ways to reach Manhattan.

In 1932, the number of commuters had grown to 213 (compared to only 13 from Carle Place), by 1936 there were 230, in 1941 there were 288, in 1953 there were 1,280 and by 1962 the number had increased to 1,613.

From Horses to Airplanes

Nowadays, there are thirty-two trains that stop in Westbury daily, including two morning trains that originate (first stop) in Westbury, and one evening express train from New York whose first stop is Westbury. The new Horizon condominium complex overlooks Westbury station (built on the site of the Luessen's Hotel, later Piping Rock) and is attractive to those professionals who want an easy commute to Manhattan.

THE WESTBURY TROLLEY

In the early days of the twentieth century, trolleys were commonplace in many American cities. They were popular in New York City before being made obsolete by subways. The New York and North Shore Traction Company ran trolleys in Whitestone, Flushing, Bayside, Roslyn and Port Washington. One branch of the line was a trolley from Mineola to Hicksville (one could actually travel all the way from Flushing to Hicksville by trolley).

The Mineola-Hicksville route (beginning at Roslyn Road in Mineola, proceeding along Westbury Avenue, Maple Avenue, Prospect Avenue and ending at John Street in Hicksville) took the trolley right through the heart of Westbury. A trolley car ran from Mineola to Hicksville, crossing Westbury along Maple Avenue starting in 1907. Trolley service was halted due to extensive floods in Westbury between January and March 1918. Apparently, too few people rode the trolleys, because service was permanently discontinued in 1920, when the company ran out of money. Bus service today follows the same route to Hicksville that the trolley did all those years ago.

THE CRADLE OF AVIATION

Orville and Wilbur Wright made their historic first flight from Kitty Hawk, North Carolina, in 1903. Within a few years, the airplane industry took off. The Hempstead Plains of Long Island was one of the hot spots of early American aviation. It was ideal for use as an airfield because the area was sparsely populated and had plenty of level, treeless ground for runways. While Kitty Hawk was known as the birthplace of aviation, this area of Long Island (encompassing Garden City, Mineola, Westbury and Uniondale) became known as the "Cradle of Aviation" because it played a big role in the development of the young industry.

The first successful flight on Long Island was in Mineola in 1909, when a Herring-Curtiss No. 1 Golden Flyer took off. Soon, the pilot, Glenn H. Curtiss (1878–1930) was setting new flight records flying out of Mineola's airfield. On July 13, 1909, he flew his plane for two miles. The next day he flew it five miles, on July 15th for six miles, on the 16th for fifteen miles and a day later he flew a total distance of twenty-nine miles, including fifteen miles at one time. He won a ten-thousand-dollar prize for his efforts.

In July 1910, a pilot named Captain Thomas Baldwin took off from Garden City and flew to Westbury, where he circled over the Meadow Brook Hunt Club and the village. This was

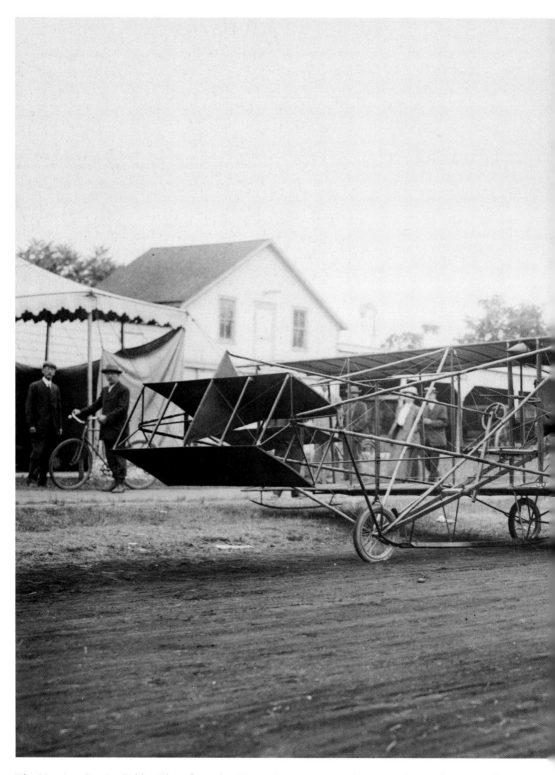

The Herring-Curtiss Golden Flyer, flown by Glenn Curtiss at Mineola, 1909. *Photograph courtesy of the Library of Congress.*

From Horses to Airplanes

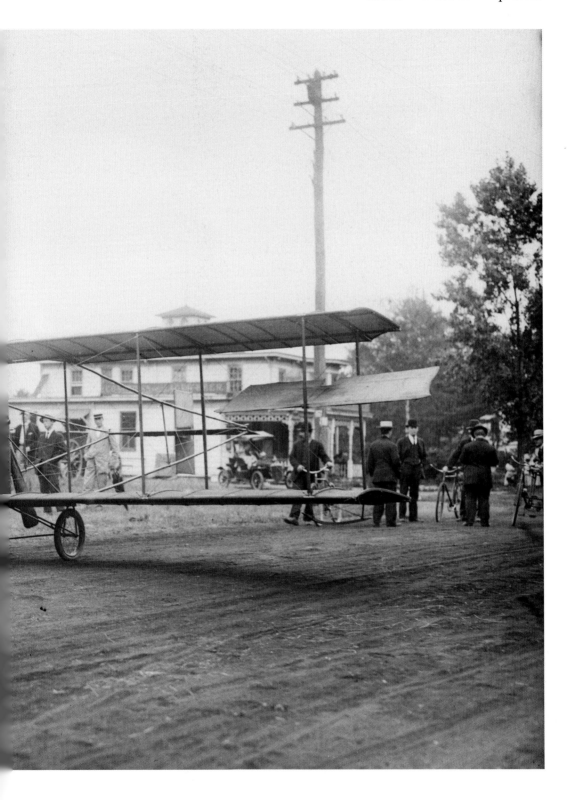

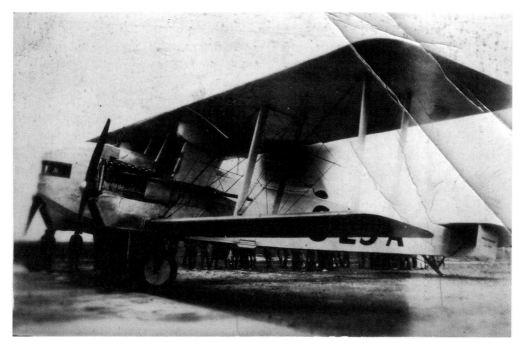

A Sikorsky S29A plane, made at the factory in Westbury, mid-1920s. *Photograph courtesy of the author.*

probably the first instance of an airplane over Westbury. The sight of airplanes in the sky over Westbury was something to which residents would soon become accustomed.

Largely because of Glenn Curtiss, the aeronautic industry on Long Island was born. Besides flying fields at Mineola, nearby Roosevelt Field was built in 1917 as a World War I airfield. It was named in 1918 after President Theodore Roosevelt's son Quentin, who had trained there before being killed in action. Near Roosevelt Field were Hazelhurst Field (built 1915, merged with Roosevelt Field in 1929) and Mitchel Field (built 1917) in East Garden City. By 1921, Roosevelt Field had four hangars and was considered the best field on Long Island.

Though traditionally Garden City has been given all the credit, Westbury played a major role in the development of early airplanes. Because the original Roosevelt Field was partly located in Westbury (including runway and buildings) and flight patterns often took planes directly over Westbury, airplanes were very much a part of life in 1920s and 1930s Westbury.

A Russian immigrant named Igor Sikorsky started to build airplanes in Westbury during the early 1920s. Sikorsky had arrived in the United States in March 1919. He faced some rough financial times at first, until he was aided by a fellow Russian, the famous pianist Sergei Rachmaninoff. The five thousand dollars in aid that Sikorsky received helped the fledgling company considerably, and Rachmaninoff became a vice president of the Sikorsky Aero Engineering Company. Sikorsky soon manufactured the S-25 and S-26 planes.

From Horses to Airplanes

In May 1924, a large biplane invented by Sikorsky took off on a test flight from Roosevelt Field. The plane, carrying nine people, later crash-landed on the Salisbury Golf Course in Westbury. No one was seriously injured, and Sikorsky kept working on perfecting this plane, with a wingspan of seventy feet. Capable of carrying twenty passengers, the plane was soon making regular flights of several hundred miles. By the end of 1926, the plane, called the Yorktown, had made its five hundreth flight, carried over four thousand passengers and had logged 281 hours in the air. At the time, Sikorsky lived on the corner of Henry and Butler Streets in Westbury. The company's operations eventually moved to Connecticut. One of Sikorsky's biggest contributions to the field of aviation was the helicopter, which he invented during the 1930s.

A French World War I flying ace named Captain Rene Fonck (1894–1953; he downed seventy-five enemy planes) spent much time at Roosevelt Field, preparing for a transcontinental flight. Fonck was well aware that a businessman named Orteig had offered a twenty-five-thousand-dollar prize to the first person(s) who flew an airplane non-stop across the Atlantic Ocean. Fonck was so eager that he even worked with Westbury-based Sikorsky to make suggestions about the plane's design.

Fonck took off in a Sikorsky model S-26 at 6:20 am on September 21, 1926, attempting to make a much-hyped first transatlantic flight (from New York to Paris). The plane traveled about 3,200 feet down the runway before it veered to the left. It was later speculated that the plane's load was simply too heavy. The plane skipped into the air only briefly. Captain Fonck tried to land the plane but was unsuccessful. The right wheel of the landing gear buckled and fell off and the plane flipped disastrously onto its right side. Nassau County Deputy Sheriff Carl Fulling was on the scene and tried in vain to approach the burning wreck. A crowd of curious onlookers jockeyed for a position near the wreckage, but they were held back by the deputy. Fonck himself was not seriously

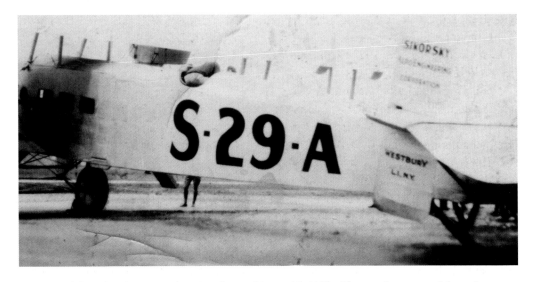

Closeup of the Sikorsky S29A, showing the marking, mid-1920s. *Photograph courtesy of the author.*

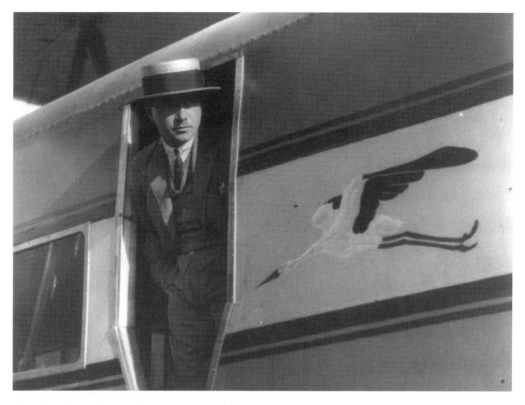

Rene Fonck in the doorway of a Sikorsky airplane, 1926. *Photograph courtesy of the Library of Congress.*

injured in the accident. Unfortunately, the plane's radio operator, a Frenchman named Charles Clavier, died in the accident. Igor Sikorsky attended the funeral mass that was said at St. Brigid's Church on September 25th.

Transatlantic Flight

It would not be Fonck, but the young Charles A. Lindbergh (1902–1974), son of a Minnesota congressman, who would ultimately make the historic nonstop solo flight across the Atlantic. In the spring of 1927, Lindbergh spent time at Roosevelt Field with his plane, the *Spirit of St. Louis*, preparing for the flight. He went into Westbury Village for refreshments at the Meadowbrook Pharmacy. For more than a week, there was electricity in the air in Westbury. People felt they were about to witness something very historical. Lindbergh and his mechanics prepared diligently.

The weather was questionable the evening of May 19, but a little before midnight, Lindbergh decided he would make the attempt the next morning. He slept for just two hours in his room at the Garden City Hotel, then arose at around 2:00 a.m. By the time Lindbergh arrived at the field, there was already a crowd of people gathered. Lindbergh's plane was filled with 451 gallons of gasoline. He had with him five sandwiches for the

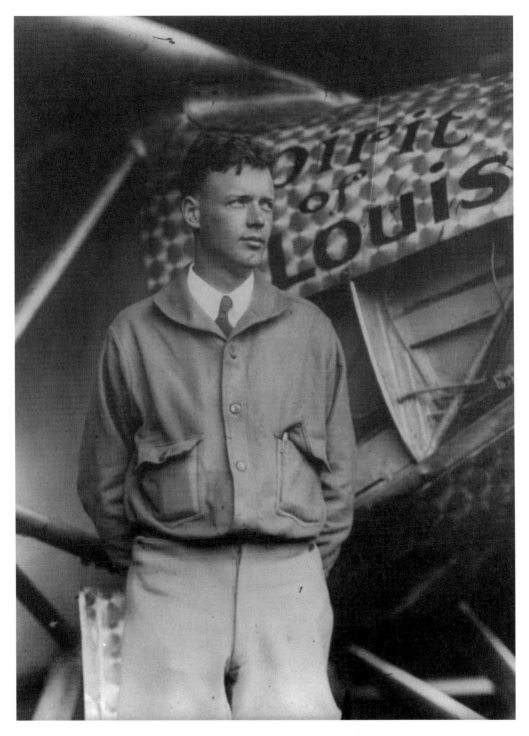

Charles Lindbergh and his plane, the *Spirit of St. Louis*, 1927. *Photograph courtesy of the Library of Congress.*

long trip. He started down the runway at 7:52 am. For a few tense moments, it looked as if the plane would not lift off. Finally, the nose lifted, and the plane just barely cleared a tractor and then telephone wires. After thirty-three and a half hours in the air, Lindbergh's plane touched down in Paris. He was an instant hero.

Hilda (Harris) Finger, the daughter of bicycle shop owner Arthur Harris, recalls the day Lindbergh left:

> *Everybody was so excited and everybody was out to see what was going on. We could see the plane in the air from the Village, taking off. There was nothing else around* [to obstruct the view]. *My dad pointed it out to me. My sister was there at Roosevelt Field…Father had a customer named Mr. Rose, who had a nursery on Jericho Turnpike and was going to Roosevelt Field to watch. Father trusted him. He said, "You could take my daughter Estelle." He put her on his shoulders so she could see better, because there were so many people around.*

Westbury resident Joseph Sharkey (born 1894) also remembered the Lindbergh days:

> *When Lindbergh was here I knew his mechanic. Jerry Van Wagner was his mechanic. And I used to take my family over there every night. We were expecting to go every night. We used to go over there and see him, and my children used to sit in the plane because I knew the mechanic…I was there every night before he left* [for Paris].

Commander Richard E. Byrd, who had flown over the North Pole the year before, was also hoping to fly the transatlantic route from Roosevelt Field, but experienced problems and was delayed. He ultimately took off with a crew of three in his Fokker multi-engine plane, the America, a month after Lindbergh.

Not long after Lindbergh's historic flight, plans were made to preserve the runway from where Lindbergh took off, as a monument to the accomplishment. The plans fell through, but Lindbergh's flight did serve to help the popularity of flying on Long Island. Out of about 2,600 licensed pilots in the United States in 1928, nearly 10 percent of them were registered in the state of New York alone. The exact spot where Charles Lindbergh's *Spirit of St. Louis* took off is located today behind the Fortunoff Mall and is marked by a sculpture of Lindbergh's plane in flight.

Aviation grew by leaps and bounds after Lindbergh's landmark flight. Just four years later, in 1931, the famed Texas-born aviator Wiley Post took off from Roosevelt Field on a quest to break the record for flying around the world. He and his navigator, Harold Gatty, beat the old record of twenty days by twelve days, landing back on Long Island after only eight days.

Westbury Plane Crashes

The village was the scene of a horrific accident when a plane crash occurred in the very center of Westbury, at the intersection of Post Avenue and Maple Avenue on November

27, 1929. A young pilot named James Pisani had rented a plane from Roosevelt Field. It soon crashed into the porch of Daniel McLoughlin's real estate business at the corner of Maple and Post, and then landed in the center of Maple Avenue. Pisani was killed, but no one else died. Eerily, it was not the only crash in the area that day. Amazingly, just two hours later, a large Fokker thirty-passenger plane piloted by S. Marshall Boggs crashed into the home of Arthur Wicks on Jamaica Avenue in Carle Place. Though the pilot was only slightly injured, fire destroyed both the Wicks home and the neighboring house of Joseph De Biever. Amazingly, the several neighborhood children who were playing on the street at the time were not injured. A crowd of about twenty thousand people from Carle Place, Westbury, Mineola and other towns came to view the wreckage. Manufacturer Anthony Fokker blamed the crash on human error. Captain Eddie Rickenbacker, American flying ace of World War I, even visited with the people whose homes were destroyed.

In fact, plane crashes were fairly common in the area, as it was so close to the flying field. On June 29, 1930, two army officers were killed when their plane crashed in the Salisbury Golf Course. On May 26, 1935, a female pilot from Manhattan, Friedel Braun, was doing stunts in the air over Westbury when her plane crashed into the roof of Richard Martorelli's house on Concord Street in Westbury. Braun was killed and her passenger injured, but miraculously, nobody in the house was hurt. In September 1935, Herbert Ottewell was doing stunts in his biplane when he was forced to parachute out. The plane crashed in a field, but Ottewell floated to the ground safely on the Westbury property of S. Baltazzi.

The End of an Era

The eastern part of Roosevelt Field (about 260 acres) was used to create Roosevelt Raceway in 1936, but the western portion continued to operate full throttle, so to speak. The aviation school headquartered there made Roosevelt Field very popular. More than 250 planes were stationed at the field by about 1940. During World War II, the airfields of the Hempstead Plains were a key part of the war effort, with soldiers being encamped there.

In June 1951, Roosevelt Field finally closed. With the growing population, other land uses were rapidly becoming more valuable. The closure set the stage for another development of the same name—a mammoth shopping mall. Mitchel Field closed in 1961, marking the true end of an era in central Nassau County.

Post Avenue
The Heart of Westbury

Post Avenue, named after a prominent Westbury family, runs north-south between Jericho Turnpike and Old Country Road. It has been the nerve center of the Village of Westbury for more than one hundred years, the go-to place where virtually anything could be found—from horse feed and saddles to ice cream and candy to socks and shoes. In its original configuration, Post Avenue near Jericho Turnpike was further east of its current location, cutting through the Quaker property before meeting Jericho Turnpike.

In the late nineteenth century, it was mainly St. Brigid's Church, farms, a couple of stores and residences that dotted the avenue. Post Avenue came into prominence with the construction of the McKenna Building south of Maple Avenue, part of the first business block. During the first two decades of the twentieth century, numerous buildings rose along Post Avenue. Though originally built to serve the needs of the population of Old Westbury to the north, as time passed more and more people began to settle in Westbury proper. The businesses could now serve the residents of both communities, as well as those who worked at the Roosevelt Air Field and the Meadow Brook Hunt and Polo clubs.

The development of Post Avenue happened quickly between about 1900 and 1925. Some of the buildings that were constructed during those years were small, narrow affairs of one or two stories in height. A few were larger, such as the Tudor-style building at the corner of Post and Drexel, and the three-story Deferrari Building at the corner of Winthrop and Post. The most developed area of early Post Avenue was the blocks immediately to the north of the railroad station. The corner of Maple Avenue and Post Avenue was a central location for the settlement. The building at the southwest corner of Maple and Post, currently Benny's Ristorante, has been a restaurant and/or hotel over the years and an anchor on the corner since the late nineteenth century. Photographs from the early decades of the twentieth century depict a dirt road lined with plentiful shade trees.

S. Marvin Barley ran a popular drugstore at 167 Post (founded 1890), offering medicine, chemicals, sick room supplies, cigars, perfume, stationery, ice cream soda and dentistry, among other things. Beginning in 1915, a pharmacist named Charles Bauer opened the Meadowbrook Pharmacy on Post Avenue, several blocks north of Barley's. The store offered the same goods as Barley's, but also had a soda fountain and a few small tables. Bauer had trained in New York City, and moved to Westbury from Hempstead. Once the theater opened across the street in the late 1920s, crowds would cross Post Avenue and

A History of Westbury, Long Island

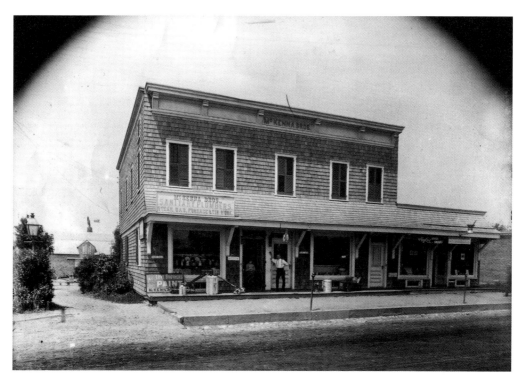

The McKenna Building (seen in 1901) was one of the earliest business buildings on Post Avenue. *Photo courtesy of the Historical Society of the Westburys.*

A Post Avenue home (either Barley or Tatem), circa 1900. *Photograph courtesy of the Historical Society of the Westburys.*

Post Avenue—The Heart of Westbury

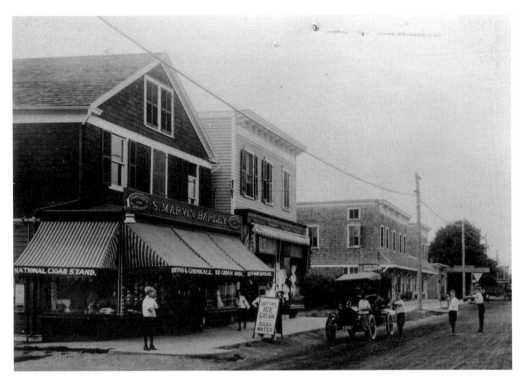

Barley's Pharmacy at its second location on Post Avenue, early 1900s. *Photograph courtesy of the Historical Society of the Westburys.*

get refreshments after their movie let out. The shop was open late, from 7:00 a.m. to well after 11:00 p.m.

In the early days, there was McCarthy's store on upper Post Avenue, which sold a few groceries, penny candy, five-cent ice cream cones and school supplies. There was also a general store near the rail crossing, first called Kelsey's, then Schwickers. The Westbury Coal Yard was established in 1885 by the Hicks family and was located on the south side of the railroad tracks. The Luessen's Hotel was another important building in early Westbury, immediately convenient to the railroad station at the corner of Post and Union Avenues. It was built around 1890 and run by Anna Luessen and her husband, who bought the property with the aid of a loan from Mrs. Luessen's father. In the golden years of the early twentieth century, Luessen's was just one of several hotels in Westbury.

There were also a variety of blacksmiths, hardware stores, saddleries and other horse-related shops. Barley's and the Meadowbrook both sold horse supplies. The Fox and Ellison blacksmith shop was located on Post Avenue north of where the Northern State Parkway currently crosses through Westbury. Edwin Hicks remembered watching horses being shod at the blacksmith's shop when he was eight years old:

> *I admired seeing the blacksmith build up his forge fire with big hand bellows, heat up a piece of steel, shape it on an anvil and weld on the heel of the horse shoe; a bar to give*

An advertisement for Barley's, 1929. Both the Meadowbrook Pharmacy and Barley's sold horse supplies. *Photograph courtesy of the author.*

Post Avenue—The Heart of Westbury

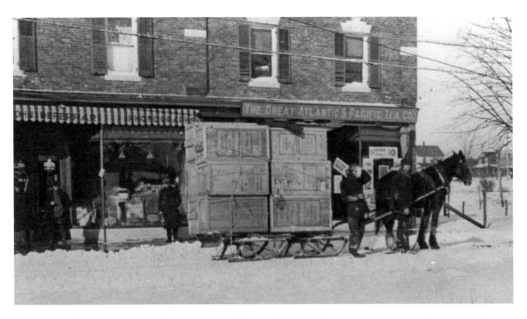

A shipment of phonographs is delivered to the Deferrari shop, early 1900s. *Photograph courtesy of the Historical Society of the Westburys.*

the horses traction particularly in winter. The blacksmith would then bend over and hold each horse's leg while he held the horseshoe against the hoof, heated up the shoe in the fire and then hammered it to the shape wanted on the anvil. This would be repeated until a desired fit was obtained when the shoe would be nailed to the hoof.

Whatever early-twentieth-century Westbury residents could not find on Post Avenue could always be ordered by mail from Sears Roebuck. The 1909 mail-order catalog included a rocking chair for $3.95, a mantle clock for $2.32, a bed with mattress for $7.95, a piano for $89.00, a violin for $3.85, a typewriter for $22.95 and a 100-piece Austrian china dinner set for $13.95.

The first bank in town, the Bank of Westbury, opened in 1910 with just two employees. In 1924, the bank relocated to a new building at the corner of Maple and Post (still standing; for years it was the Bank of New York, now it is Chase). Another bank, the Wheatley Hills Bank, was first opened during the mid-1920s. Its home was on the corner of Scally Place and Post Avenue (in the building that was later to become the Nassau County Republican Headquarters).

Many families became well known because of their Post Avenue businesses. One of the most well-known families was the Italian Deferraris. The Deferraris had, at various times, a clothing store, a stationery store, a radio/phonograph store, a real estate agency and a liquor store. Brothers Louis and John Deferrari ran the radio store, with the help of Louis's son, Louis Jr.

As the village grew, there were numerous places to eat. Luncheonettes, restaurants, ice cream parlors, pubs, candy shops and other eateries abounded. The very popular

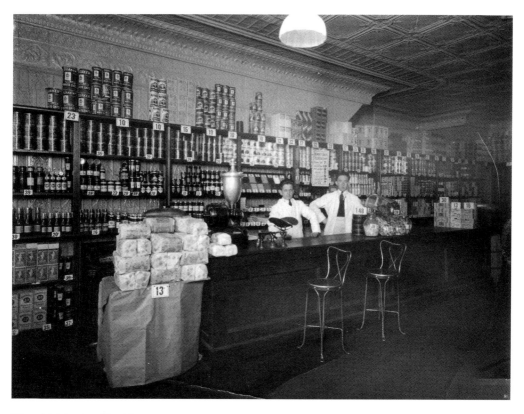

The old Atlantic & Pacific store on Post Avenue, circa 1920s. *Photograph courtesy of the Historical Society of the Westburys.*

Wheatley Hills Tavern was founded in the 1930s and was run by the Zaino family until the 1990s. It was one of the hot spots in town; by mid-century it was catering big Westbury events and functions, both civic gatherings and private parties. Though the name of the establishment has changed, it has remained a restaurant to this day.

Food shopping was also a necessity for the many new inhabitants of Westbury Station/Westbury Village. A walk down to Post Avenue during the 1920s and 1930s yielded a wide variety of meats, fruits, vegetables and baked goods.

Besides butcher shops and fruit stores, there was a Bohack's market at the corner of Post Avenue and Maple Avenue. There was also an Atlantic & Pacific store in the Deferrari Building at Post Avenue and Winthrop Avenue in the early years of the twentieth century. The ancestor of the modern-day A&P, this was a small, friendly store. The Great Atlantic and Pacific Tea Company was first founded in 1859 in Elmira, New York. By 1915, they had more than 1,500 store locations. The A&P eventually moved across Post Avenue, near the intersection with Maple.

Some of the offerings in the early twentieth century Westbury A&P store included Quaker hominy grits for ten cents, a can of pink salmon for eight cents, Jell-O for seven cents, Quaker Corn Meal for ten cents, catsup for fifteen cents, dates for seven cents, salt for seven cents, a loaf of bread for thirteen cents, a large jar of A&P olives

Post Avenue—The Heart of Westbury

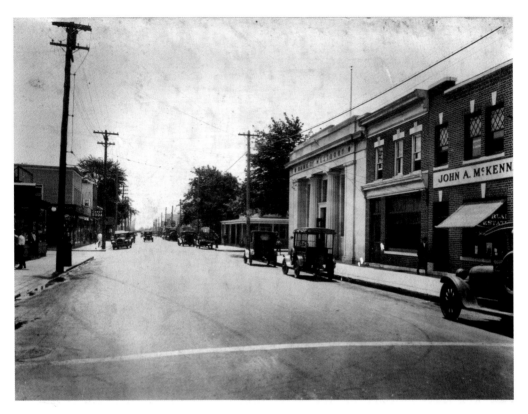

The intersection of Post and Maple Avenues, late 1920s. *Photograph courtesy of the Historical Society of the Westburys.*

for thirty-nine cents, matches for five cents, salad dressing for twenty-nine cents and A&P Grandmother's Pancake Flour for thirty-five cents.

By 1927, Westbury had numerous clubs and associations, including the American Legion, Catholic Daughters of America, Epworth League, Religious Society of Friends, Free and Accepted Masons, Knights of Columbus and the Order of the Eastern Star. Among the groups with the largest memberships were the Neighborhood Association (150 members) and the Westbury Board of Trade (175 members; founded 1919).

Entertainment could be had at the Westbury Theater, built in the late 1920s in Tudor style. Before that, movies were shown on the second floor of the old firehouse on Post Avenue. Later (1940s) there was a pool hall upstairs in the old firehouse. Plenty of other recreational activities took place in Westbury, from social gatherings at one of the several ice cream or candy shops, to sports events at school, to roller skating and ice skating at the Westbury Pond (now in Old Westbury).

The years 1929 and 1930 were eventful for Westbury and for Post Avenue. In November 1929, a small plane crashed at the intersection of Post and Maple Avenues. Then, just before midnight on February 2, 1930, the fifty-year-old drugstore owner Charles Bauer, proprietor of the popular Meadowbrook Pharmacy, was shot and killed

> **PLEASE DO NOT HANDLE**
>
> INSTALLED BY
>
> **DEFERRARI'S MUSIC SHOPPE**
>
> 235 Post Avenue Telephone 100 Westbury, Long Island

A sign from the Deferrari shop, circa 1930s or 1940s. *Photograph courtesy of the author.*

by two unmasked robbers whom he had chased as they panicked and attempted to flee the store. The robbers had entered the drugstore just as a crowd of moviegoers was leaving the theater. The two men fled in a car waiting outside. The thieves were caught just twenty minutes later in a massive countywide police dragnet. Hilda Harris Finger remembers that fateful night. Her father, bicycle shop owner Arthur Harris (who was close friends with Charles Bauer), told his children to stay put as he ran to the scene of the tragedy. A temporary pharmacist took over until Bauer's sons completed their pharmacological training and took over.

Despite these incidents, tragedy was the exception on Post Avenue. Most Westbury residents have fond memories of Post Avenue during the twentieth century. When did Post Avenue reach its zenith? That really depends who you ask. Post Avenue in 1930 was a thriving place, but so was Post Avenue in 1950 or 1960.

The Post Avenue of the mid-twentieth century had a wide variety of businesses, restaurants, and shops of all kinds. With the intense population growth that Westbury experienced during the 1950s (incredibly, the population doubled between 1950 and 1960), Post Avenue became a truly vibrant Long Island downtown.

Nino's on Post Avenue was a place where you could get fine food, including wild game. Nino himself was an enthusiastic hunter. The prices at Nino's Restaurant (formerly Luessen's Hotel and later Piping Rock) on Post Avenue in 1954 were as follows: tea, 15 cents; coffee, 25 cents; ice cream, 35 cents; boiled potato, 40 cents; slice of pie, 50 cents; clam chowder, 50 cents; French fries, 60 cents; ham sandwich, 75 cents; salad, 75 cents; turkey sandwich, $1.00; hot turkey sandwich, $1.75; spaghetti and meatballs,

$2.00; broiled pork chops, $2.50; Long Island duckling, $3.00; frogs' legs, $4.00; steak for two, $11.00.

Even into the 1970s, there were plenty fruit and vegetable markets, butchers and meat markets, gift shops, stationery stores, variety stores, candy shops, luncheonettes, taverns, restaurants and hardware stores/appliance stores on Post. Many a Westbury child enjoyed the variety store called Smiles; it offered an enticing array of cheap toys, sewing supplies, candy, school supplies and seasonal merchandise. Into the 1970s and 1980s, Post Avenue still had a hardware store and a paint store. Stefan's Bake Shop provided rolls, rye bread, Danishes and crumb buns to an eager crowd. Peter Prommersberger, formerly of Manhattan Avenue, remembers going to Stefan's beginning in 1956:

> *What I remember most on Sunday mornings, was it that felt like half the village was there. There was a line from the counter circling around inside the store and sometimes out the door. It was the busiest retail establishment in Westbury. And you never failed to meet a neighbor there.*

Through the early 1990s, the Westbury downtown continued to be a thriving place that had an identity all its own.

A Trip Down Post Avenue

Over the years, hundreds of different businesses have graced the storefronts of Post Avenue. If you stepped into a time machine, this is what you'd see along Post over the years. (Numbering starts at Old Country Road and go up as you go north along Post. Businesses preceded by an "*" are discussed at the end of each section.)

Post Avenue in 1929

Westbury in 1929 was a growing community. Post Avenue had really begun to come alive during the 1920s. At 140 Post was the Patsie Russo Family Shoe Store; at 207 was John A. McKenna (real estate and insurance); at 223 Samuel Tear (formerly known as A. Fabricant's; novelties, confectionery, smokers' supplies, stationery, newspapers, cameras, tobacco); at 234 was Louis's Shoe Shoppe; at 243-245 the Ellison Electric Co. (hardware, paints, oils, radio sets and supplies); and at 249 Hamilton R. Hill (insurance and real estate). At Post & Maple were the Harris Auto Company (auto repairs), Harris, Harris and Harris (auto insurance), and the Bank of Westbury. At Post & Madison was J. Broderick Cohen (dentist). In the Theatre Building were N. Fusco Custom Tailor, Theatre Tonsorial Parlors (hair salon) and Dr. Charles J. Robinson (dentist). At Post & Belmont was M.J. Knipfing & Sons (automobiles).

Also along Post Avenue were (street addresses uncertain): G. Abbatiello Meat Market (beef, lamb, pork, veal); Albert F. Schwicker (Chrysler dealer); American Restaurant; M.

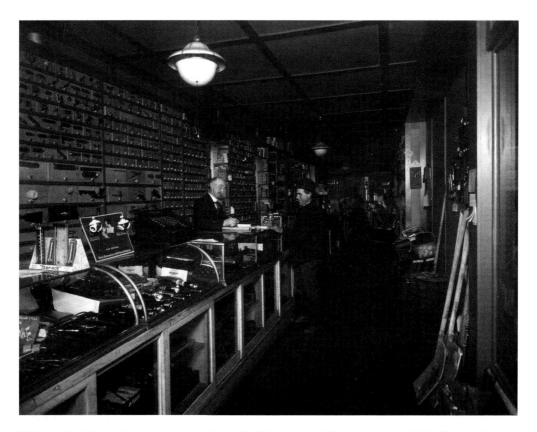

William Conklin behind the counter of Lascelle Hardware at 229 Post Avenue, 1922. *Photograph courtesy of the Historical Society of the Westburys.*

Baum (cigars, tobacco, sporting goods, stationery); I. Brown Custom Tailor; F.A. Carle's Place (horse goods and dog supplies); C&H Crouchley (horse transportation); Deferrari's Music Shoppe (radios, phonographs, records); Anthony Deferrari (real estate and insurance); Goldberg Furniture Company (furniture, household decorations, bedding, floor coverings); Joffone's (fruiterer & grocer); C&E Krupp (beef, veal, mutton, lamb, pork, poultry, game, butter, eggs); Anthony Lagnese Sanitary Barber Shop; A.M. McCarthy (staple and fancy groceries); John McDonnell (real estate); McKenna Brothers (sanitary and heating engineers); Marquette's Lunch; Meadow Brook Pharmacy ("Prescriptions filled in a safe, satisfactory way."); Post Avenue Barber Shop; Renison & Doyle (plumbing, heating and sheet metal work); Rudolph's Delicatessen; I. Schack, United Cigar Store (sporting goods, newspapers, magazines, stationery); Russell C. Sherman (dentist); S. Baskin (watches and jewelry); *Edward W. Staab (hardware, tinware, crockery, paints, oils, garden implements, tools); Vesuvius Spaghetti House; Gustav H. Weber (saddle and harness maker); Westbury Bakery; Westbury Candy Kitchen; Westbury Coal Yard; Westbury Meat Market (in the Roche Building); *Westbury Hardware Company, Inc. (hardware, paints, oil, lawn mowers sharpened and repaired); Wheatley Taxi Service; and Zaino Custom Tailor.

Post Avenue—The Heart of Westbury

*The old-time hardware store was a magical place where you could find all manner of tools, paints and old-fashioned nuts and bolts; in effect, it was a variety store for home repairs. One could go into a hardware store and spend a few cents for some nails, or buy a large and expensive tool. During the last twenty years, most of Long Island's independent hardware stores have vanished. The "big box" home supply store has supplanted the mom-and-pop hardware store.

Post Avenue in 1950

By 1950, Westbury had grown tremendously. A small sampling of the businesses along Post shows at 15 Post Avenue was Dom's Auto Repairs; at 39 the Post Tavern ("Do not divorce your wife if she cannot cook, come to us."); at 117 was the Westbury Coal Yard, Inc. (fuel oil, coal, wood and masonry materials); at 152 was Robert's Floor Coverings (tile, linoleum, paints, wallpaper, carpeting); at 154 the *Westbury Appliance Co. Inc. (repaired televisions, refrigerators, washers, stoves, radios, phonographs); at 163 was Jay's Stationery ("The Friendly Place to Shop."); at 168 was Wheatley Hills Tavern (seating capacity of five hundred, dancing nightly); at 173 was *Glynn Appliances, Inc. (repaired radios, washers, freezers, televisions, refrigerators); 178: Abbott's (frosted foods, delicatessen and specialties); at 179 the Westbury Studio of the Fine Arts, Inc. (dance instruction by Mrs. Kall and Mrs. Waldecker); at 181 was E.W. Staab Hardware & House Furnishings; at 182 was the Westbury Fruit & Vegetable Market ("If it Grows we Have it."); at 183 Seymours Department Store; at 186 the Anthony Barone Barber Shop; at 188 Wheatley Hills Stationers (stationery, toys, magazines, newspapers); at 193 Smiles Stores (5 and 10 cents, $1.00 and up); at 207 Nelson & Baldwin Surveyors; at 208 was Westbury Curtis-E Taxi; at 217 was Bake Shop, Inc.; at 219 Carmine J. Lagnese (real estate and insurance); at 223 I. Brown's Men Shop (shirts, sports wear, hats); at 231 was Friar's Bar & Grill; at 235 the Westbury Gift Shop (everything from greeting cards to luggage); at 237 Tear & Gershon (toys, cigars, stationery, greeting cards, athletic equipment); at 253 the Westbury-Roslyn Fish Market; at 259 *Cavallaro Home Appliance (repairs and sales for refrigerators, washers, freezers, televisions, radios); at 263 the Westbury Trading Post (hardware, housewares, paints, brushes); at 278 Westbury Launder-It. Also on Post was the Bohack Food Market at Post and Maple, and Barney McGuire (horseshoer).

*One of the big changes over the years has been technology. During the early to mid-twentieth century, many new gadgets and appliances were invented. Following the phonograph, which was invented by Thomas Edison in the late nineteenth century, came the radio, television, washer, dryer and refrigerator. These early appliances were large and heavy and filled with wires and a variety of electronics and nuts and bolts. When one broke down, it was usually out of the question to buy a new one. For a fraction of the cost of replacement, you could bring your appliance to a repair shop. These shops were plentiful; as you can see, Westbury in 1950 had at least three such shops. Sometimes a shop served as an authorized repair location for a particular

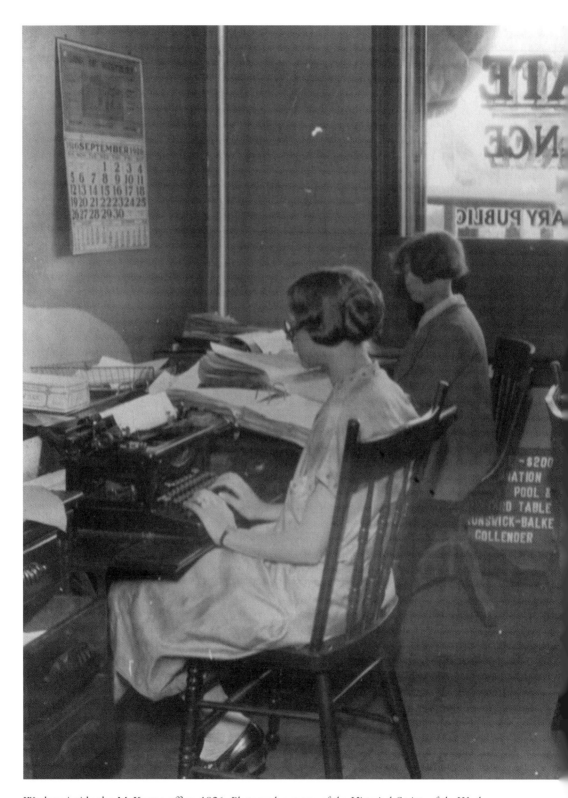

Workers inside the McKenna office, 1926. *Photograph courtesy of the Historical Society of the Westburys.*

Post Avenue—The Heart of Westbury

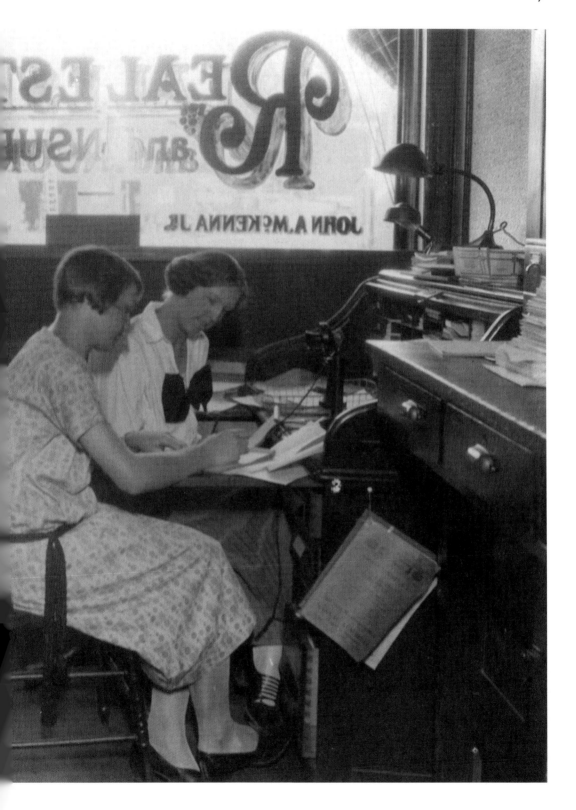

brand. Repairmen could take your appliance apart and replace various parts to get the appliance in working order again. Though all of these same appliances still exist today, and may have some resemblance to their older counterparts on the outside, the "nuts and bolts" are completely different. Cheaper production costs have made it much more affordable to buy a new appliance, and the advent of complex computer circuitry has made it harder to repair broken ones. Once common, appliance-repair shops have all but vanished from the scene.

Post Avenue in 1956

Between 1950 and 1960, Westbury experienced its greatest growth. Post Avenue continued to thrive. At 140 Post was Russo's Shoe Store; at 151 was *Rocco's Stationery and Luncheonette; at 153 the Meadowbrook Lunch; at 162 the Martini Shoe Store; at 167 was Barley's Pharmacy; at 169 the Westbury Wine & Liquor Store; at 170 Wheatley Hills Tavern; at 181 was Staab's Hardware; at 183 Seymour's Westbury Department Store ("Clothes for the Entire Family."); at 186 Salisbury Market (meat and poultry); at 191 was the I.G.A. Food Market; at *193: Smiles Stores (variety); at 209 Joffone's (fruit and groceries); at 211 was Wheatley Hills Chemists; at 215 *Joe Allen's United Cigar Store (stationery, toys, chocolates); at 220 the Wheatley Market (meat, groceries, frozen foods); at 229 was Edward C. Etzel (insurance); at 234 Louis Parillo Shoe Store; at 237 was *Tear & Gershon (variety, baseball equipment); at 239 Deferrari's Liquor Store; at 249 the Meadowbrook Pharmacy ("Where quality is obvious, confidence is the natural result."); at 251 the Westbury Sport Shop; at 253 the Westbury & Roslyn Fish Market; at 254 was Edward & Son Jewelry Company (in theatre building); at 255 the Meadowbrook Meat Market; at 259 Cavallaro Home Appliances; at 261 was M. Ferraioli (Italian/American groceries, homemade spaghetti sauce); at 265 was M.J. Knipfing & Sons (Ford sales/service); at 272 Abete's Restaurant; at 278 the Westbury Launder-It; at 287 was M.W. Tear Optometrist; at 289 The Red Box (gifts); at 311 the Westbury Plate Glass Co.; and at 341 was Westbury Federal Savings Bank. At Post & Castle was the Meadow Brook Flower Shop (Robert Renison, proprietor); at Post & Liberty was the Wheatley Hills Service Station; and at Post & Wilson was John J. Dowling (Chrysler/Plymouth sales/service).

*The stationery store and variety store were common during the mid-twentieth century. Back then, it was common for people to keep in touch with pen and paper, mailing each other handwritten letters. Besides, long-distance phone calls were expensive. Stationery stores provided pens, pencils and paper of all types, as well as envelopes and other related items. With the advent of the office supply store, computers and cheap copy paper by the ream, the need for stationery stores disappeared. All that remains today are card stores that sell greeting cards and small gifts.

The variety store was a wondrous place, filled with an eclectic mixture of items. The death knell for variety stores was when Woolworth's went out of business several years ago. The old-fashioned variety store has now been replaced today with the dollar store. Whereas you could find virtually anything you needed in a variety store, the dollar stores

Post Avenue—The Heart of Westbury

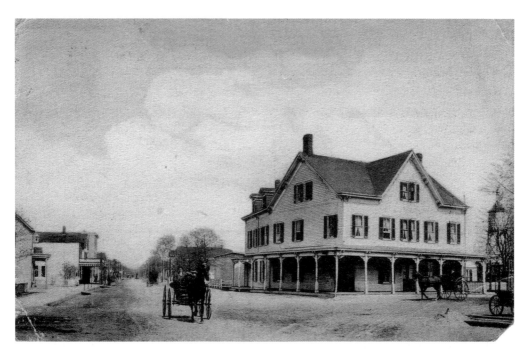

Postcard showing Luessen's Hotel on Post Avenue, circa 1911. *Photograph courtesy of the Historical Society of the Westburys.*

of today offer a more limited menu of items, mainly cheap imports and manufacturer overstock; just try to find buttons or shoelaces in a dollar store.

Post Avenue in 1969

Despite the development of Old Country Road, Post Avenue remained a real downtown in 1969. At 25 Post was Chicken Delight; at 53 the Westbury Flower Shop and Greenhouse; at 134 was Andy's Paddock (clothing); at 141 was Henry's Taxi; at 143 D. Popino Plumbing and Heating; at 147 was Noel Vincent, Ltd. (gifts); at 153 was Red's Barber Shop; at 157 was Frank's Pizza; at 162 was Alex's Italian Pastry; at 167 was *Barley's Pharmacy; at 170 the Wheatley Hills Tavern (restaurant, cocktail lounge, banquet/catering); at 173 was Renata Delicatessen; at 178 Harri Photographers and Miss Evelyn Bridal Consultant; at 180 Pride of Italy Deli; at 186 was Frohmann's Meat Market; at 215 was Joe Allen's United Cigar Store (pipes, tobacco, stationery, candy, toys, papers, magazines, greeting cards); at 216 was Shirl's Luncheonette (featuring homemade ice cream); at 217 Stefan's Pastry Shop; at 224 the Shamrock Bar & Grill ("Ye Foremost Irish Inn."); at 239 was Deferrari's Liquor Store; at 241 was Ellison's Hardware; at 247 was Edward and Son Jewelers; at 249 the *Meadowbrook Pharmacy; at 259 The Alley Sport Shoppe (guns, ammo, archery, fishing tackle, bowling balls); at 261 Ciccone's Italian-American Deli; at 263 Zorn's Professional Dry Cleaning ("For people who

care."); at 265 M.J. Knipfing and Sons, Inc. ("Long Island's Oldest Ford Dealer."); at 272 was Abete's Restaurant Bar and Pizzeria; at 276 was Safeco Insurance; at 285 was A-1 Plumbing and Heating; at 290 Dial Chevrolet Inc.; and at 307 John J. Dowling Plymouth Chrysler Imperial.

*Pharmacies were a staple in old-time Westbury, with several on Post Avenue, including the historic Barley's Pharmacy. The old-fashioned drugstore was legendary for its refreshments. As the old legend goes, the movie star Lana Turner was discovered while sipping soda at a drugstore. Unlike other types of businesses, the pharmacy has not vanished in today's world; it has only evolved. Most independent pharmacies have closed due to the rise in chain pharmacies. These new super-pharmacies are really part supermarket, part variety store and only a small part drugstore. They sell canned, dry and refrigerated and frozen food and drinks, as well as candy. They sell greeting cards, tissues, diapers and offer photo developing services. Typically, they operate out of much larger buildings than their older counterparts and are able to offer cheaper prices. But not everyone prefers them.

Post Avenue in 1982

During the 1980s, many of the old-time Post Avenue businesses were still around, but things were beginning to change as old-timers died or moved away from Westbury. At 117 Post was Hicks-Westbury Oil; at 130 was Piping Rock Restaurant; at 151 was Garo's Fine Catering; at 163 Alfredo Pizzeria; at 167 was Barley's Pharmacy; at 169 was Westbury Wine and Liquor; at 170 was the Wheatley Hills Tavern; at 174 was a salon called DeLeo Lagnese; at 175 the Minuteman Press; at 181 The Cheese Barrel (gifts); at 183 was Renata's Deli; at 184 was *Post Fruit and Vegetable; at 185 was Tony's Haircutters; at 190 Williamson's Paint and Wallpaper; at 220 *Frohman's Wheatley Market (meat, fruits and vegetables); at 229 Edward C. Etzel (insurance); at 231 was Friar's Tavern; at 234 Parillo's Shoes; at 237 Tear & Gershon (variety); at 241 was Ellison's Hardware; at 247 the Westbury Pharmacy; at 248 Hempstead Bank; at 263 Zorn's Dry Cleaners; at 282 Sir Speedy Printing; at 306 was C-Town; at 307 V-World Motors (foreign cars); at 311 was Westbury Plate Glass; at 313 Margaret V. Colvin Realty; at 317 was Post Cleaners; at 321 was Van Cleef Realty; at 341 Westbury Federal Savings & Loan and at 342 Kraemer & Mulligan (lawyers).

*Throughout its history, Post Avenue has been a one-stop shopping place for food. Fruit and vegetable markets and butcher shops were more common in the old days. As supermarkets grew more popular from the 1950s and on, consumers no longer relied as much upon the local fruit market or butcher. In recent days, the fruit and vegetable market has made a resurgence, offering better prices than supermarkets on many items.

Painted sewer pipe from the Post Avenue Sewer Pipe Contest, 1979. *Photograph courtesy of the Prommersberger family.*

A History of Westbury, Long Island

Recent History of Post Avenue

As times have changed, so has Post Avenue. Like other Long Island villages, the businesses of downtown Westbury faced new challenges during the last decades of the twentieth century. Superstores, strip malls, warehouse stores and department stores all drew more business away from Post Avenue. The concept of a village centered around Post Avenue changed over time, as the Salisbury neighborhood to the south of the village became more populated and Old Country Road and Carman Avenue were developed.

Another factor in the decline of Post Avenue as a destination is the rising prevalence of the worldwide web as a way to shop. With low overhead and fast service, web-based stores are able to offer low prices and attract customers who can purchase with the click of a mouse and then await the package delivered to their front door without having to set foot outside.

The Westbury Business Improvement District was founded in 1993 to help keep Post Avenue a vibrant place and attract new businesses. Inevitably, perhaps, during the late 1990s and early 2000s, Post Avenue lost many old standbys as shop owners retired and times changed. Parillo's shoe store closed in 1997 after seventy-seven years in business.

To the chagrin of many Westbury residents, Stefan's Bake Shop closed in the late 1990s. Soon after, the second location of Stefan's, in a shopping center on Old Country Road in Westbury, also closed.

And it was also a sad day when the old variety store Tear and Gershon closed in the early years of the twenty-first century. Even in its last days, Tear and Gershon was a throwback to an earlier era in Westbury, offering a wide variety of items, everything from greeting cards and padded envelopes to cut flowers and ceramic knickknacks to toys to lottery tickets, newspapers, candy and chewing gum. They were known as the local source of helium-inflated balloons for parties and a drop-off point for advertisements in the local free weekly paper. The store also had a selection of dollar items. In the spring, a selection of reasonably priced flowering plants and vegetable seedlings would make a colorful display in front of the store. Café Gino's opened there in May 2007, bringing new life to an old space.

The landmark Barley's Pharmacy and the Midville Pharmacy both closed in early 1998, within a few weeks of each other. These closings coincided with the opening of a Rite Aid drugstore adjacent to the corner property at Post and Maple. Founded in 1962, Rite Aid has more than 4,000 locations nationwide. The store is the modern idea of a drugstore, featuring a pharmacy, drinks, snacks, candy, a photo developing lab, toys, beauty supplies and cleaning products.

Several historic materials from Barley's were donated to the Historical Society of the Westburys. Barley's briefly became Bailey's, an antique store that utilized both the main floor and the basement of the building. The shop sold a wide selection of furniture, glassware and other antiques briefly until the owners moved their business elsewhere.

The Westbury Theater showed its last film in 2001. The demise of the theater was sad; the building had decayed, and it had to be shut down for safety reasons. It was sold in 2004 for a price of $1.65 million to a developer.

Post Avenue—The Heart of Westbury

Other changes continued to come on Post Avenue. A Subway fast food restaurant opened and then a Dunkin' Donuts opened in 2005. The flavor of Post Avenue has shifted many times, depending on the type of shops that line the street. At one time in the late 1990s, Post Avenue had two antique stores, Cobblestones and Bailey's (located in the old Barley pharmacy building), but by 2005, both shops had closed. The jewelry stores were also gone by 2005. Butchers, bakeries, fruit and vegetable stores have seen their numbers reduced. Businesses offering services (nail salons, tax preparation offices, real estate agencies, etc.) rather than goods have become more prevalent.

Things are looking up for Post Avenue, however. Street fairs and parades continue to attract large crowds. The construction of a piazza in the center of the village was finally accomplished in 2006 after the village acquired the gas station property at the corner of Maple and Post. Inlaid with decorative cobblestones and landscaped with shrubs and trees, the square is the cornerstone of the newly revitalized Westbury. Dedicated in April 2007, the village square is a throwback to an earlier era and encourages pedestrian traffic. It is not a suburban park with a parking lot adjacent to it; it is an urban piazza, meant as a stopping point for those who stroll casually down Post Avenue. The revitalization of Post Avenue will hopefully bring new prosperity to its merchants.

More to Westbury than Post

Of course, Post Avenue was the heart of Westbury, but as the settlement grew and developed through the early twentieth century, more and more businesses opened along other roadways besides Post Avenue.

By 1929, Maple Avenue, Union Avenue and School Street had a variety of shops and businesses. On Maple, you could go to C. Lagnese for produce and groceries; to V. Imparato, the tailor; to George Hesse Jr., the plumber; or to the Maple Leaf Barber Shop. On Union Avenue, you could find Vincent Wawryck, who sold meat, groceries and vegetables; Thomas Nunziato, who sold groceries, meat, fruit and vegetables; and Joe Abbatiello, who sold dry goods. You could go to the Triangle Service Station at Union Avenue and Seaman Court or to the Samson Electric Shop at the corner of Union and School Streets. Several businesses were also located on Grand Street, Butler Street and other streets in the village.

Westbury residents also found entertainment outside of Post Avenue, especially on Brush Hollow Road (outside the boundaries of the village).

When it first opened in 1957, the Westbury Music Fair was a modest affair, basically a theater under a large tent. In the 1960s, a larger and more permanent facility was built. Since then, the names of the stars who have appeared at Westbury read like a who's who list of twentieth century musical and comedy favorites—Judy Garland, Maurice Chevalier, Sammy Davis Jr., Jack Benny, Milton Berle, Liberace, Jerry Lewis, Carol Channing, Tim Conway, Bob Hope, Rodney Dangerfield, Engelbert Humperdinck, Paul Anka, Don Rickles, Perry Como, Danny Thomas, Raquel Welch, Liza Minelli,

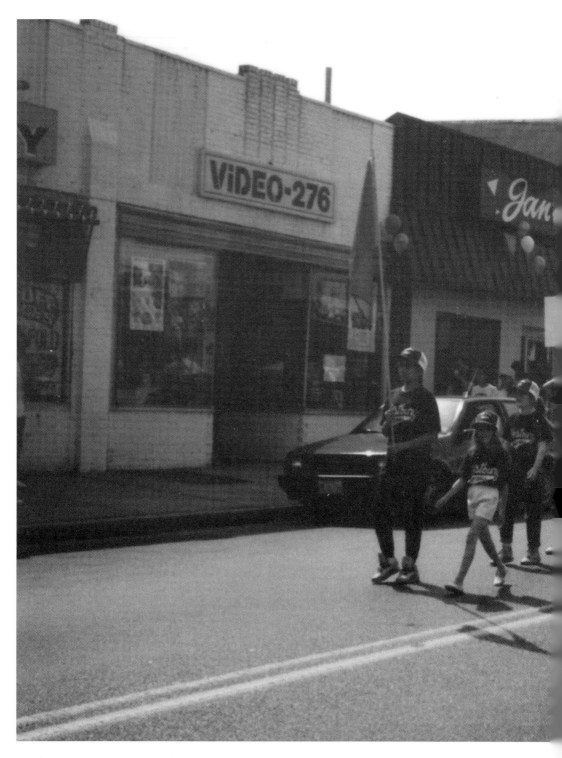

Parade on Post Avenue, 1990. *Photograph courtesy of the Ingoglia family.*

Post Avenue—The Heart of Westbury

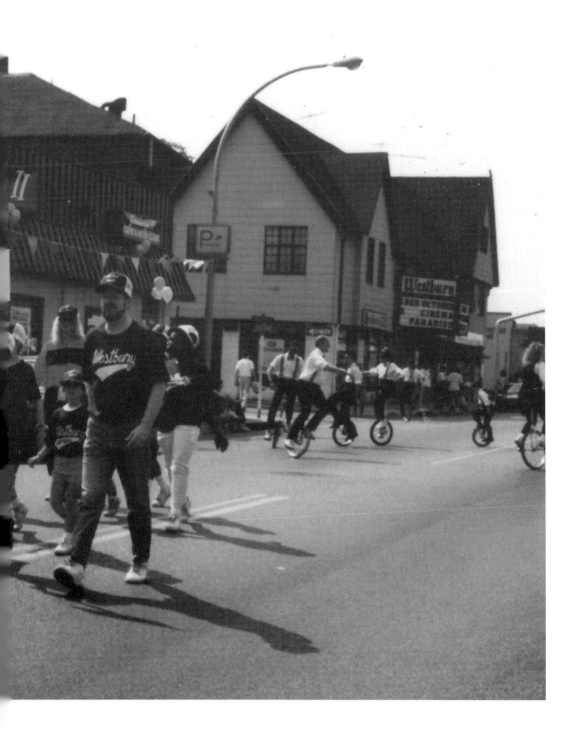

A History of Westbury, Long Island

Huey Lewis and the News and Ringo Starr. Some shows are performed in the half round for a more intimate evening.

The now-defunct Westbury Bowl, also on Brush Hollow Road, opened in 1961 and for decades attracted large crowds of eager bowlers of all ages. The nearby Westbury Drive-In movie theater, opened in 1953 and closed about forty years later.

Hotels in Westbury

Transportation improvements such as the railroad and the automobile had a big impact on the growth and development of Westbury. Equally important was the development of excellent infrastructure. As early as 1904, people were bragging about the good roads that Long Island offered. Getting to Westbury was fairly easy, and in the years before it became a suburb, Westbury served as a pleasant country retreat. This was especially true given the foxhunts and polo games that took place in Westbury.

In the early years of the twentieth century, numerous hotels were to be found in Westbury. These were small hotels each offering several rooms. The best known and most centrally located was Luessen's at Union and Post Avenues (directly adjacent to the railroad station). There was also Schmidt's Hotel on Old Country Road and Post Avenue, Hesse's Hotel on Grand Boulevard and Cross Street, the Westbury Garden Inn at Ellison and Maple and the United States Hotel (later the Greentree Inn) at Post and Maple. These hotels served a variety of clientele, from men visiting Westbury on business to summer vacationers looking to spend some time in the "country," away from the bustle of New York City to visitors coming to see polo matches or auto races.

As Westbury continued to develop, these village hotels began to close down or convert to restaurants. The new Westbury accommodations of the 1950s and 1960s were the Holiday Inn, the Island Inn and the Town and Country Motel (across from the Raceway), all on Old Country Road. These hotels were larger than their older counterparts and catered more to the one-night stays of visitors. Gone were the days of weeklong vacations to the countryside of Westbury. The Island Inn was eventually torn down to make way for retail space.

Old Country Road

While the stretch of Jericho Turnpike that crosses through Westbury remains even today minimally commercial, Old Country Road to the south has become a bastion of shopping and dining. For many kids growing up in the New York metro area, the only reason they knew of Westbury was from the television commercials for Coronet. The store, which sold children's furniture and more, ran a series of amusing commercials during the 1970s and 1980s that prominently announced the address "Eleven eleven Old Country Road, Westbury—and no talking orangutan!"

Post Avenue—The Heart of Westbury

Right: Fortunoff, Old Country Road in Westbury, 1963. *Photograph courtesy of the Prommersberger family.*

Below: Ad for the Clam Box Restaurant, circa 1940s/1950s. *Photograph courtesy of the author.*

Visit the CLAM BOX for Sea Food at its best. John Lee, Famous Chef, direct from Fishermen's Net Sea Food House in N. Y. C. You'll always find the food delicious, the service particular, and the prices more moderate than you dared expect. Bring your friends to share your discovery of the delightful CLAM BOX.

CLAM SEA FOODS BOX

JOHN LEE, Famous Chef

Steaks • Sea Food • Chops

SHORE DINNERS OR A LA CARTE
FAMILY SUNDAY DINNERS AND SMALL PARTIES
Opp. West Gate Roosevelt Raceway, Old Country Road
WESTBURY, LONG ISLAND
THOMAS DENA, MGR.

38764 PRINTED BY BROWN & BIGELOW, ST. PAUL, MINN., U.S.A.

Shopping has been synonymous with Old Country Road since the 1960s. Fortunoff, a department store founded in Brooklyn in 1922 by Max and Clara Fortunoff, had opened a flagship store at Old Country Road and Ellison Avenue in 1964. The Fortunoff Mall, also known as the Mall at the Source, is a thirty-eight-acre complex that opened in September 1997. With 500,000 square feet of new retail space and more than sixty stores, the mall cost $145 million to build. Despite the big price tag, business was soon booming as word spread about the mall. With a nice variety of stores selling clothing, accessories, chocolates and candy, music, books and candles, the mall presented a less daunting outing than the nearby Roosevelt Field in Garden City. It also offered restaurants and a naturally lit food court atrium. Of course, it also helped that the anchor store was Fortunoff.

Besides Fortunoff, there was the popular department store, Ohrbach's (opened 1963 at a cost of $6.5 million). The 185,000-square foot store employed around one thousand people, including numerous Westbury residents. In the 1980s, the store became Steinbach's before being demolished to make way for the Source Mall.

For decades, Old Country Road has also been a popular destination for dining. For example, during the 1960s, you could eat a seafood meal at the Cherrystone Inn at 477 Old Country Road (across from Fortunoff), which featured clams, lobsters, steaks and sandwiches. Or perhaps you might want to eat at the elegant John Peel restaurant located in the Island Inn. There was also the twenty-four-hour service of the Dobbs House Restaurant at 644 Old Country Road. And then there was Libby's Diner and Bar across Old Country Road from the Roosevelt Raceway (diners of various names have been a mainstay on Old Country Road for years). For decades, the Gam Wah Chinese restaurant was popular with the raceway crowd and with local families. It was known for its excellent food and was also a sight to see in its pagoda-style building. Old Country Road also became a popular location for gas and service stations, including Parkway Cities Service Station at Mirabelle Avenue and Scappy and Peck Auto Body at Bond Avenue.

The increasing development of Old Country Road and later the Raceway property as a shopping district has meant a lesser role for Post Avenue but greater prominence for the rest of Westbury. Westbury today is a thriving weeknight and weekend destination for shoppers, diners and moviegoers.

Religion in Westbury

St. Brigid's Church

Religion has always been an important part of life in Westbury. For more than 170 years, the Quakers were the dominant religious group. Then, with a surge in immigration into the country during the middle of the nineteenth century, an influx of Irish Catholics arrived on Long Island. In the late 1830s, the nearest Catholic church was in Jamaica, Queens, which at the time was a two-mile carriage ride to Hempstead, then a seven-mile trip on the Long Island Rail Road. Prior to that, the closest Catholic church had been even farther away, in Brooklyn.

By coincidence, the Reverend James O'Donnell stopped at the home of an Irishman named Bernard Powers on the Hempstead Plains (near present-day Uniondale) one Saturday evening in about 1839. Father O'Donnell stayed the night and said Mass there the next morning. The attendance at that Mass was said to be seven people, including the Powers's neighbors, the O'Haras, who had been invited for the occasion. It was the first Catholic Mass to be said east of Jamaica.

Construction of an actual Catholic church in Westbury was begun about 1850. A committee composed of James O'Hara, Bernard Powers and Thomas McCormick helped collect funds. The archbishop purchased two acres of land from a Quaker named John Titus for the price of $140. As the Reverend Thomas Code (pastor of St. Brigid's at the time) wrote in the Centennial Journal in 1956: "In 1856, Bishop John Loughlin, the first Bishop of Brooklyn, came to Westbury to dedicate the first church in Nassau County. The little wooden structure was built opposite the railroad station and was dedicated in honor of St. Brigid of Ireland." In the early days of the church, attendance on Sundays was about two hundred.

Colorful characters have long been a part of St. Brigid's parish. In early August, 1883, Patrick Kearney, pastor of the church, threw a picnic for Catholics in Westbury in surrounding areas. A splendid time was had by all, until a man from Oyster Bay joined the festivities and got into a fight with a Westbury man over the right to dance with a certain girl. A large-scale brawl broke out among the crowd, until the powerful and charismatic Father Kearney stood on a table and told the crowd he himself would punch any one who made trouble.

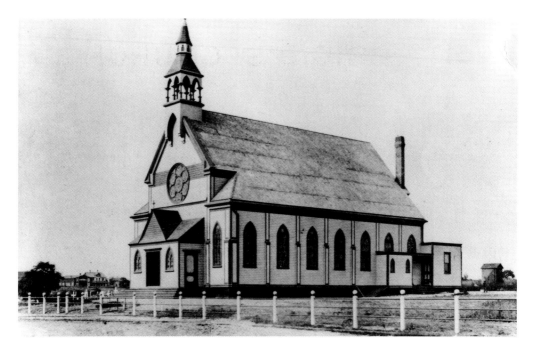

The St. Brigid's Church, 1894. *Photograph courtesy of the Historical Society of the Westburys.*

During the 1890's, the Reverend Father Thomas McGronen, a graduate of St. John's College in Brooklyn, raised several thousand dollars to build a new church at Westbury. He also said the first Catholic Mass in New Hyde Park and helped get the Church of the Holy Ghost (now Holy Spirit) built there. The new St. Brigid's church in Westbury (with a seating capacity of 520 people) was begun in 1894. It was completed the next year at a cost of $7,000. Among other expenditures in 1894 were $99.20 for coal and wood; $500 for clergy salaries; $163 for a sexton; $14.10 for vestments and vessels; $43.78 for a horse; $30.27 for sundries, $63.97 for rectory furniture and $27.75 for insurance. Though the new building was a major expense, the church received thousands from donations and collections throughout the year, including a special "cornerstone collection" ($121.25), and upon its opening, the church was debt-free.

The growth of the parish proceeded at such a rapid pace that the 1894 church soon became too small to handle the needs of Westbury's Catholic population. On October 3, 1915, thousands watched as the cornerstone was placed for a new, larger Norman-style structure by the Reverend Maurice Foley, Bishop of the Philippines. Granite blocks were hauled in from New York City on the Long Island Rail Road. The new fifty-thousand-dollar church was dedicated in May 1916. Meanwhile, the 1894 building was painstakingly moved (with the help of horsepower) across Post Avenue to its present location in a process that took several months. It is said Mass was still celebrated in the old building as the church was in the process of being moved across Post Avenue. The old church was to serve as the first St. Brigid's School.

Religion in Westbury

> **ST. BRIGID'S CHURCH**
> WESTBURY, N. Y.
>
> QUARTERLY PEW RENT OF *Mrs. A. McCarthy*
>
> From *Nov. 1,* to *Feb. 1, 1919*
>
> PEW NO. *25* AMOUNT $ *3.25*
>
> Received Payment *de McGinnis*

Pew rental receipt, St. Brigid's 1919. *Photograph courtesy of St. Brigid's School.*

Mayor Ernest Strada (born 1930) lived close to St. Brigid's growing up—perhaps too close. Recalls the mayor:

> *The convent was on the corner of 5th [and Post]. There was nothing between the convent and our home. So the nuns who taught could look out the window in the evening and see our kitchen lights on. And they would know what time we went to bed because if we had company and my parents were up late, the lights were on late. I'd go to school the next morning and they would say, "Mr. Strada, we know you were up late last night because you probably had visitors."*

Due to the growing population of neighboring Carle Place, in 1938, the Reverend Loksley Appo opened a Mission Chapel in Carle place in a former store. As Levitt and Sons built hundreds more homes in Carle Place in the 1940s, the community soon outgrew the original facilities. Under the leadership of Father James Sullivan, Appo's successor, a new and much larger brick-faced, Colonial-style Mission Chapel was built in Carle Place. The first mass was said in the lower church in 1954, and the entire building was completed in 1955 (dedicated June 19, 1955, by Bishop Raymond Kearney) at a cost of about $250,000. In 1987, Carle Place became its own parish, Our Lady of Hope. The 1954 building still stands today. To help pay for the Chapel and the construction of the new St. Brigid's school, more than $300,000 was raised from parishioners. A convent was built on St. Brigid's Lane in the 1960s to house the many nuns who taught at the school because they had outgrown their

St. Brigid's as it appeared in the 1920s. The new church is at left, the 1894 church is at right, across Post Avenue. *Photograph courtesy of the Historical Society of the Westburys.*

old building on Post Avenue. The building was later rented to the Nassau County police.

The St. Brigid's parish in its centennial year of 1956 was a thriving community, with numerous societies and clubs, including the Ushers Society, the Sodality of Our Lady, Ancient Order of Hibernians, A.O.H. Auxiliary, the Tone Trotters choir, the Chapel Senior Choir, Rosary Society, the Altar Society, the League of the Sacred Heart, the Nocturnal Adoration Society, the First Friday Breakfast Committee, the Society of St. Vincent de Paul, the Confraternity Staff, the St. Brigid's Young-Adult, the Durazzano Society, the Durazzano Ladies Auxiliary, the Altar Boys Society, the Parents Club, the Christian Family Movement, the Holy Name Society, the Dell'Assunta Society, the Knights of Columbus, the Hospital Committee, the Columbian Squires, the Columbiettes and the Fife and Drum Corps.

The church was closed for renovation in 1984. The pews were refinished, the electrical system refurbished and the church painted and rehabilitated. During construction of a new altar, a time capsule tin box placed there in 1939 was found. It contained a set of rosary beads, two medals and newspaper articles from the *NY Journal American*. The note enclosed in the box read:

> *This altar was built on August 23, 1939 to commemorate the first mass said in this part of Long Island on hundred years ago. Pius XII is the Pope of Rome, Thomas E. Molloy the Bishop of Brooklyn, Reverend Maurice Lichford and Reverend Brunswick Morgan are assistants in this parish and Locksley Aloysius Appo the Pastor who to the glory of God and the honor of his blessed Mother anchored this box in the altar with a humble prayer for peace.*

When renovations of the church were completed, it was rededicated on November 17, 1985, by Bishop John McGann of the Diocese of Rockville Centre.

During the late twentieth century, St. Brigid's earned a reputation as one of the most ethnically diverse parishes in New York. The winner of the 1996 Pulitzer Prize for Beat Reporting was Bob Keeler of *Newsday*, for his in-depth reporting in a series of articles on many facets of the eclectic St. Brigid's parish in Westbury.

Twice a year, carnivals are held in the St. Brigid's School parking lot. The St. Anthony Society holds a carnival in June and the Dell'Assunta Society, founded in 1911, holds a carnival every August. These festivals bring numerous families and end with fireworks displays. The St. Brigid's School Parents Association also holds festivals and craft fairs in the school parking lot.

The sixty-five-acre Cemetery of the Holy Rood (one of three Catholic cemeteries in the Diocese of Rockville Centre) stretches between School Street and Post Avenue, Old Country Road and Railroad Avenue. Though it was technically founded in 1930, it includes the much older St. Brigid's Church cemetery, which dates back to the mid-nineteenth century. The oldest graves in the cemetery are located nearest to the church. Some of the families represented in the old St. Brigid's section include the following: Agnew, Anderson, Behm, Behr, Braun, Butterly, Callan, Coehner, Couchlan, Courtney, Deferrari, Dowling, Duff, Eckert, Gaffney, Gibney, Gleckler, Hickey, Hoyes, Hassman, Iannaccone, Knipfing, Kotoski, Kreischer, Lagnese, Lauck, Leahy, Lottermann, McCarthy, McCue, McCunnicle, McKeever, Markert, Moran, O'Hearn, Quinan, Reinhard, Scally, Schlick, Small, Stattel, Stolz, Withopf, Wolf and Zaino. Many of these date to the late nineteenth and early twentieth centuries.

Among the earliest dated stones are several that are mostly illegible, dating to the 1850s and 1860s. One stone is for a child named Margaret Murphy, who died in 1852. Other early stones are for Mary Murray (died 1873), Michael Scanlan (died 1877), Frank Murray (died 1878), Rose Anne Kelly (died 1879), Ann Hagerty (died 1881), Kate Powers (died 1882), Daniel McLoughlin (died 1884), Daniel Kinsella (died 1885), Michael Dineen (died 1885), Silas Bender (died 1891) and Elizabeth Wohlfender (died 1894).

Among the clergy buried in Holy Rood are the Reverend Lawrence Fuchs, pastor of St. Ignatius Church in Hicksville (died 1923); the Reverend John J. Fitzsimons, pastor of Corpus Christi Church in Mineola (1869–1913); Monsignor Charles Canivan of St. Dominic's Church in Oyster Bay (1877–1944); and the Reverend Locksley Appo, pastor of St. Brigid's from 1935 until his death in 1943.

The cemetery now has a computerized, searchable index of burials by last name.

CATHOLIC TRADITIONALIST CHURCH

The Catholic Traditionalist Movement (CTM) was begun in 1965 by Belgian-born Father Gommar A. De Pauw (1918–2005). The movement was a direct reaction against the Second Vatican Council's decision to do away with Latin-language Mass. Three

First communion ceremony at St. Brigid's, 1961. *Photograph courtesy of the Prommersberger family.*

Religion in Westbury

A History of Westbury, Long Island

The Methodist Church and parsonage, Belmont Avenue and Fulton Street, early twentieth century. *Photograph courtesy of the Historical Society of the Westburys.*

years later, in 1968, with the persistence of Father De Pauw and a woman named Gloria Cuneo, the Ave Maria Chapel was opened in an attractive stone building at 210 Maple Avenue, just west of Post Avenue. The building was formerly the home of the Holy Trinity Ukrainian Orthodox Church and before that the home of the Lutheran Church of the Redeemer (1941–1958). The Ave Maria Chapel is the headquarters of the CTM. Hundreds of people attend the masses at Ave Maria each Sunday.

Methodist Church

Though Quakers and Catholics were the majority during the nineteenth century, as more people moved to Westbury, new churches were built. The original early-twentieth-century Methodist Church of Westbury used to stand on Belmont Avenue at Fulton Street. In 1950, it moved to its current home on Asbury Avenue, adjacent to the Northern State Parkway and very near to Post Avenue. The Methodist community today is still going strong with several hundred parishioners.

The old Belmont Avenue building was converted into an art gallery in 1953. During September and October 1959, a benefit show was held featuring paintings on loan from Arthur Hays Sulzberger, the publisher of the *New York Times*. Among the artworks on display were paintings by politicians such as President Dwight Eisenhower and former British Prime Minister Sir Winston Churchill. The old church building is now gone; its

Religion in Westbury

The AME Zion Church's original nineteenth-century building as seen circa 1910s/1920s. *Photograph courtesy of the Historical Society of the Westburys.*

site is the parking lot of the office building on Post Avenue between Belmont and Lewis Avenues.

African Methodist Episcopal (AME) Zion Church

The church was first organized in 1834 as the New Light Baptist Church. It was originally located at the present-day intersection of the Long Island Expressway and Glen Cove Road. The wooden structure was moved to Westbury in 1867 so as to be more convenient to the many African Americans living in Grantville. Its founders were descended from the slaves released by the local Quakers near the end of the eighteenth century. The building was rebuilt as a brick church during the 1920s. It is located on a triangle of land situated between Cambridge Avenue and Church Streets, off Brush Hollow Road. Families who are buried in the cemetery include Delamar, Jackson, Blakely, Albertson, Roe, Pickering, Beauchamp, Lassiter, Levi, Seaman, Badger, Bunn, Watkins, Carman, Pearson, Warren, Hicks and Payne. Some of the early stones are too faded to read, but among the oldest legible stones are those for William Jackson (1836–1914), Peter Johnson (died 1893), Ellen Mitchell (1811–1898), James Payne (1825–1907), Eugene Bunn (1874–1893), James Bunn (1876–1907), Charles Hicks (1821–1913), Henrietta Hicks (died 1893), Ida Kissam (born 1862), Fountain Johnson (1861–1918), Charles Levi (1840–1908), Townsend Levi (died 1911) and Susan Levi (died 1916).

Church of the Advent

The elegant stone Episcopal Church of the Advent (located just off Jericho Turnpike, at Advent Street) was built in 1910, designed by the famous architect John Russell Pope (1874–1937; he later designed the National Archives building, National Gallery of Art, and Jefferson Memorial in Washington, D.C.). Mayor Ernest Strada's great-uncles, who were masons, helped lay the stones of the church.

In June 1914, the Church of the Advent was the scene of a fantastic society wedding between Martha Bacon and George Whitney. The church was decorated in flowers for the event and the ceremony was performed jointly by the rector, Richard Pope, and the Reverend Endicott Peabody, who had served as the head of the Groton School when Franklin D. Roosevelt was a student there. The guest list was illustrious and included Mrs. Theodore Roosevelt, Mrs. William K. Vanderbilt, Mr. and Mrs. August Belmont, Mr. and Mrs. Henry L. Stimson, Elihu Root and Mr. and Mrs. J. Pierpont Morgan.

More Recent Additions

Of course, Westbury today has many other houses of worship besides the few discussed in some detail in this chapter, including The Islamic Center of Long Island on Brush Hollow Road (built 1991); the Westbury Hills Jewish Center (founded in 1960 and later renamed Temple Beth Torah; buildings constructed in 1963 and 1991 on Cantiague Rock Road); the Community Reform Temple (started in 1958 on Ellison Avenue in Westbury, merged with another temple and moved to The Plain Road in Salisbury) and the St. Andrew's Byzantine Catholic Church on Ellison Avenue (founded in 1974). The Korean Evangelical Church graces the corner of Ellison and Maple.

Westbury Today
Old Meets New

Westbury today is a pleasant mixture of new and old, of history made and history in the making. In any discussion about Westbury now, it is important to mention what traces of old-time Westbury are still standing.

Historic Westbury

Unfortunately, the last vestiges of the original seventeenth-, eighteenth- and early nineteenth-century settlement are long gone in Westbury. Much of the early settlement was north of Jericho Turnpike and a few ancient structures remain today in Old Westbury. The situation in Westbury Village is different, with only a handful of nineteenth-century buildings remaining.

The oldest building in Westbury still sits quietly on the Quaker property near Jericho Turnpike. Originally built in 1830, the Orthodox Meetinghouse was constructed because the Quakers had split into two sects. The building now contains classrooms for the Friends School. Painted gray, the building retains its simple beauty. The old Hicksite Quaker Meetinghouse dates to 1902, the year when the nineteenth-century building burned down. One of the most recent historic losses in Westbury was the old mid-nineteenth-century Wilbur Lewis farmstead (on Liberty Avenue, about one hundred feet from Post Avenue), which was razed during the 1990s to make way for new housing.

One of the most notable fires in the settlement's history was the devastating four-alarm blaze that struck the Piping Rock Inn (formerly Luessen's Hotel) at the corner of Post Avenue across from the railroad tracks. It happened on December 8, 1999, leaving much of the historic old building a burnt-out shambles. The property was eventually sold and the fire-ravaged structure demolished to make way for the condominium complex known as the Horizon.

Another relatively recent fire destroyed the old building at the corner of Post and Lewis Avenues. This building, which dated to the early part of the twentieth century, had housed a television repair shop on the ground floor and an apartment on the second floor.

The elegant Victorian building that houses the restaurant now known as Westbury Manor (south side of Jericho Turnpike) dates to the 1880s. Originally owned by the Titus family, the mansard-roofed building was at first located on the north side of the Turnpike and was moved to its present location in 1910. The eighteen-room house was occupied

The historic White Building (originally owned by Ambrose Clark), Post Avenue. *Photograph courtesy of the author.*

Westbury Today: Old Meets New

by the eminent local builder John R. Hill for many years, and was for a time rented to Mrs. Robert L. Bacon. In 1946, it was reborn as a restaurant called Westbury Manor (also known for a time as Carl Hoppl's Westbury Manor—Carl Hoppl was a well-known baker). It is situated just off the south side of Jericho Turnpike, west of Carle Road). Also along Jericho is the old Hicks office (now a home), located on the Hicks Nursery property and dating to 1905. In fact, the north side of the Turnpike, now Old Westbury, has a few very old homesteads. One is the former home of Samuel and Rachel Hicks (and then Robert J. Patterson, who married into the Hicks family), built about 1884.

Among the oldest structures along Post Avenue are the Benny's Restaurant building (formerly known as Enrico's, the Greentree Inn, and before that the United States Hotel), which probably dates to the 1880s, the law offices at 342 Post (formerly the McCarthy store, circa 1890) and the brick three-story Deferrari building at 233–235 Post (about 1892). Some of the older buildings on Post Avenue still retain their distinctive look of an earlier era. Perhaps the most distinctive-looking building is the Tudor-style structure at 249 Post Avenue. Many other buildings that are about one hundred years old have been refaced or have an indistinct appearance that makes it hard to see their age. The original appearance of the United States Hotel was a far cry from the resided look of today.

One of the Westbury buildings with the most interesting stories is the Ambrose Clark house. Clark (1881–1964) was the heir to the Singer sewing machine family riches. Six hundred acres of land he owned in Old Westbury later became part of the campus of SUNY Old Westbury. An avid sportsman, Clark belonged to the Meadow Brook Hunt and was Master of Fox Hounds during the 1920s.

Though Clark had the Post Avenue house built in 1903, he sold the building in 1909. It became the property of the White family. At the time it had a large stable and a windmill (these burned down in the 1920s). The Whites remained there until 1932, but retained ownership after that. For a short time later in the 1930s, Saks Fifth Avenue used the building as a summertime shop. Later, William Donohue ran a funeral parlor from the building. By the mid-1940s, the building was empty. Some civic-minded residents of Westbury and neighboring villages sought to acquire the building and convert it into the War (World Wars I and II) Memorial Community Center. Money was raised to purchase property from the White estate. The updated building was dedicated in 1947. It also housed the Westbury Library for several years, until the library moved to its present location on Rockland Street. In recent years, the White building was also used as a senior center. Today, part of the White property is occupied by the recreation center, and part by the baseball diamond.

The Barley's Pharmacy building, across Butler Street from Alfredo's Pizzeria on Post Avenue, is another of Westbury's landmark buildings. Barley's Pharmacy was for more than one hundred years one of the most important businesses in Westbury. Originally situated in the nearby McKenna Building when it was founded in 1890, the pharmacy moved to a new building not too long after. Though it originally catered to the residents of Old Westbury, who arrived in their horse-drawn carriages, it soon became an important neighborhood store for the residents of Westbury Village. It was the first store to have telephone service, and besides drugs, sold ice cream sodas. The first proprietor

Westbury Today: Old Meets New

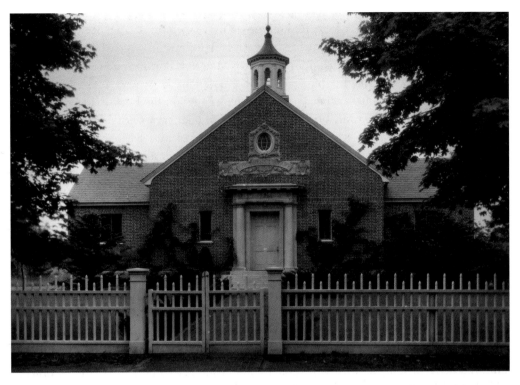

Robert Bacon Memorial Children's Library, built 1924. *Photograph courtesy of the Historical Society of the Westburys.*

Martha and Robert Bacon and grandchildren in their Westbury dining room, circa 1917. *Photograph courtesy of the Historical Society of the Westburys.*

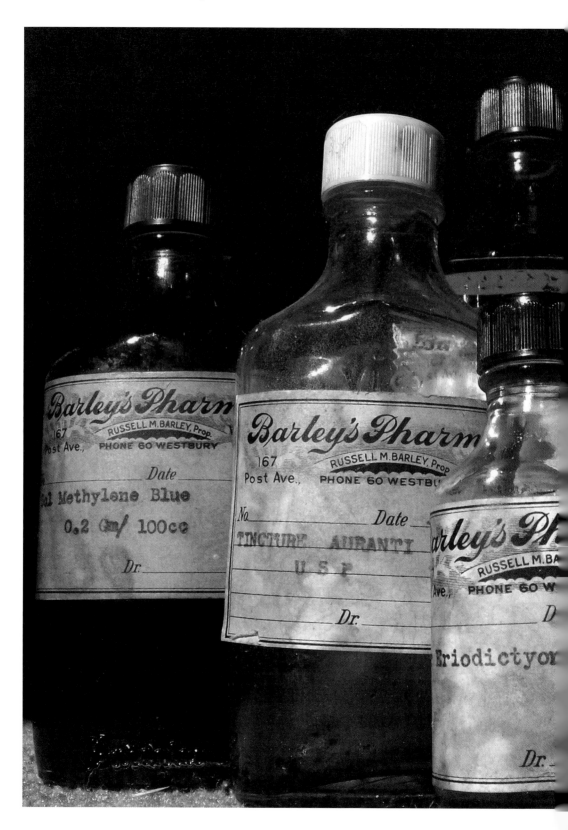

Westbury Today: Old Meets New

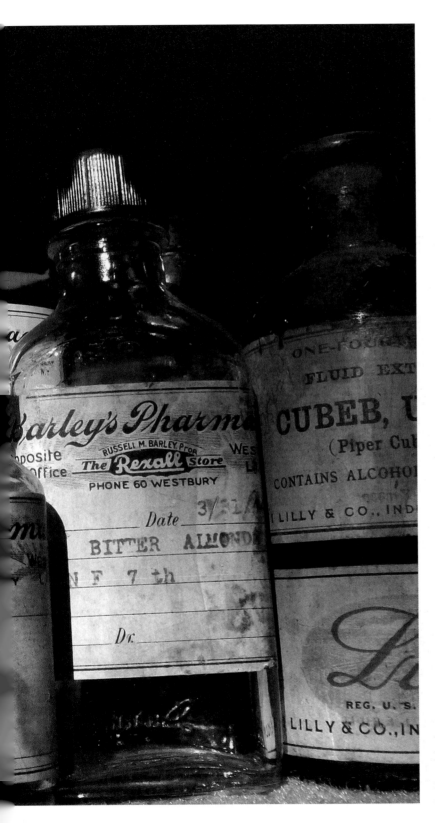

Vintage bottles from Barley's Pharmacy (circa 1940s) were saved when it closed. *Photograph courtesy of the author.*

was Marvin Barley, a native of Virginia. In 1923, his son, Russell Barley, inherited the pharmacy. Russell was well known to most Westbury residents and ran the pharmacy until 1957, when Robert Schwann took over. In 1961, Benjamin Pardo bought Barley's Pharmacy and ran it until its closing in the 1990s.

Another preserved treasure in Westbury is the Robert Bacon Memorial Children's Library, built in 1924 on School Street. At the time of its construction, it was only the third children's library in the world (after London and San Francisco). It was built as a memorial to the public servant and local millionaire Colonel Robert Bacon, a gift to Westbury from Bacon's widow. It was quite an event when the library opened in June 1924, and Mrs. Theodore Roosevelt was one of its first visitors. A local architect designed the red brick building, and the gardens were created according to Mrs. Bacon's wishes. The library still brings the thrill of reading to Westbury children today.

The Tudor-style Westbury Theater building is a unique and historic structure. For decades, it was home to a popular movie theater. By the early twenty-first century, it was in a state of disrepair that got it shut down for safety reasons. The hope is that a hole in the roof and other structural deficiencies can be corrected and the building preserved for the benefit of future generations of Westbury residents.

The original mid-nineteenth-century farmhouses of Westbury were razed long ago to make way for late-nineteenth- and early-twentieth-century homes. Today, residential Westbury retains much of the flavor of the 1920s and earlier. Most of the sturdy and attractive pre-1920 homes in Westbury are still standing. Elegant Victorians and picturesque Tudors commingle with stately Dutch Colonials.

An "Old House Survey" was distributed in 1989. Of all the entries that were submitted, the oldest house still standing in Westbury proper was deemed to be one of the three homes that was originally the Westbury schoolhouse, located now at 367 School Street and dating to the 1850s. The oldest home in the Carle Place area was deemed to be a circa-1872 Quaker structure on Roslyn Avenue that was originally a carriage house for the Phipps estate in Old Westbury. As the story goes, it was purchased in the 1920s and moved and reassembled in Carle Place. The oldest structures in Old Westbury were deemed to be a house on Clock Tower Lane built circa 1740 and the parsonage of the Evangelical Lutheran Church of the Redeemer, dating to 1840 (formerly the home of Isaac Cocks and the Quaker School before that).

A majority of the older homes have since been resided with vinyl or aluminum siding, or added to in some way. A very few houses still retain their original wood shingles, including the structure on the corner of Grand Street and Drexel Avenue (circa 1888) and another on Lewis Avenue (circa 1913). Among other old residences still standing are a pair at the southeast corner of Lewis Avenue and Fulton Street (1883), the other two homes on School Street across from the Children's Library, which made up the old Westbury Public School, and 315 Linden (1898).

Many Westbury home interiors feature fine original stained hardwood floors, Victorian crown or bulls eye moldings, five-panel interior wood doors, pocket doors, ornate banisters, built-in cabinets or cupboards and wainscoting. Some homes retain the original steam or hot water radiators, likely to be found in many different sizes and

Westbury Today: Old Meets New

The Deferrari Building, built 1890s, during the 2006 Street Fair. *Photograph courtesy of the author.*

shapes according to the needs of the particular room. A few homes have their original windows; some have interesting and attractive attic windows.

Though many of the buildings on Post Avenue date to the early part of the 1900s, by the late twentieth century, their facades were plain and indistinct from renovation or worn by age. The village of Westbury undertook a major façade renovation program beginning in the late 1990s. The purpose was to create a sense of unity among the various businesses. Indistinct signage and bland facades were seen as a contributing reason for a decrease in local business. The biggest common denominator in the façade program was new retro-style signage. Other improvements included painted stucco facing and decorative cornices and parapets. This program has helped reverse the plainness of some of the older buildings and at the same time introduce a retro look. The first business to take advantage of the program was Alfredo's Pizzeria at 163 Post. Many other buildings followed suit over the next few years.

Though the buildings are different architecturally, several stretches of the Post Avenue of today look very similar to the Post Avenue of 1930. This is especially true for the west side of the avenue between Maple Avenue and Belmont Avenue to the north. Some buildings look more obviously old than others, but all share a long and storied past. These older structures include the following (dates approximate):

149–151 Post: 1906
153: 1908
164 (Republican Headquarters; formerly Wheatley Hills Bank): mid to late 1920s.

The Village Piazza under construction at Maple and Post Avenues, 2006. *Photograph courtesy of the author.*

Westbury Today: Old Meets New

167 (discount store; formerly Barley's Pharmacy): 1907
169: 1912
201 (Chase Bank): 1923
207: 1910
213: 1914
215 (Jin's Apple Farm; formerly United Stationery): 1920
217 (El Pueblito; formerly Stefan's Bakery): 1928
221 (tailor): 1905
223 (Chinatown Kitchen): 1908
229 (offices): 1905
231 (Friar's Tavern): 1920
234 (Frame/photo shop): 1926
233–35 (Beauty supply and salon): 1892
241: 1909
245 (butcher): 1913
249A (insurance/realty): 1916
250 (theater): 1925/1927
251 (H&R Block): 1900
253 (Dunkin Donuts): 1926
257 (Bootery): 1920
261–263: 1926
285 (Total Restoration): 1900
342 (Kraemer & Mulligan): 1890

Artifacts of Westbury's Past

Besides historic buildings, other mementos of Westbury's past have been preserved. In fact, Westbury residents have been preserving their heritage for many years. The Historical Society of the Westburys, founded in 1977, serves as a repository for the collective memories of old-time Westbury. It houses a huge collection of books, photos, artifacts and memorabilia in a small cottage adjacent to the library.

Interesting relics can also be found in the ground. Among the items that have recently turned up in Westbury yards: a horseshoe, various pieces of ceramic, lots of coal and a couple of early twentieth-century German coins.

The Nassau Hub

Westbury today is recognized as an essential part of the very heart of Long Island. It is part of the area that has been dubbed the Nassau Hub. During the opening years of the twenty-first century, the Nassau County Planning Department commissioned a study of the Nassau Hub (consisting of parts of Westbury, Carle Place, Mineola, Hempstead,

Uniondale and Garden City). The study estimated that traffic in the Hub area would increase by 36 percent within ten years unless action was taken.

Westbury's part of the hub includes the Fortunoff Source Mall. Other landmarks within the hub include the Roosevelt Field Mall, the Nassau Coliseum and several museums. As the team that conducted the study discovered, one of the biggest problems with suburban reengineering is that all the components are already in place—the roads, the businesses and the residential neighborhoods. Correcting the planning mistakes of the twentieth century would have to involve a creative solution that would leave many billions of dollars worth of existing real estate untouched.

The idea was to take a detailed look into the possibility of utilizing a Bus Rapid Transit (BRT), Light Rail Transit (LRT) or Automated Guideway Transit (AGT) system. This system would link the various parts of the hub together and allow people to travel around the hub without using their cars (which could be parked at various designated locations around the perimeter of the hub. The AGT system was eliminated from further consideration due to its high cost, though implementing the BRT at a cost of $1.9 billion or the LRT at a price tag of $2.1 billion would be rather expensive as well.

Some people think that such a system, though quite expensive to construct, might help ease traffic in Westbury and surrounding areas. It would also drastically change the appearance of the southern portion of Westbury (on the south side of Old Country Road), creating a futuristic transportation loop. Other people believe that such a system would be detrimental to Westbury. Only time will tell.

WESTBURY PRESENT AND FUTURE

The ethnic composition of Westbury has evolved over the years. Following the earliest days of English settlers, there were Irish and Germans, followed by Italians. During the early and mid-twentieth century, many more nationalities came to Westbury from central and Eastern Europe. By the late twentieth century more African Americans settled in Westbury, as well as a large contingent of Central American immigrants.

Westbury has recently faced its share of challenges, including problems with illegal apartments. But businesses on Post Avenue have worked to keep up with the explosion of retail on Old Country Road and have changed to reflect the new diversity of the village. Recently built condominiums near Post Avenue have revitalized the downtown, and the Bristal Assisted Living facility offers a local alternative for elderly Westbury residents.

The most positive development in recent history is the construction of the new, landscaped village piazza, completed in time for the seventy-fifth anniversary. The dedication of the piazza in April 2007 drew dignitaries along with a crowd of hundreds, who came with pride to witness the important step in the renaissance of historic downtown Westbury. The future looks bright, indeed.

Appendix

The Government of Westbury in the Year of Its Incorporation, 1932

Mayor: Charles C. Boyd
Trustees: John H. Middlecamp, Robert S. Renison, Virgil V. McKenna, F. Joseph Ellison
Village Clerk: Madelyn Croudace/ John Dwyer
Health Officer: Dr. Francis J. Marx
Counsel: W.Y. Hallock
Treasurer: Madelyn Croudace
Fire Chief: Thomas Walsh
Superintendent of Schools: Jerome M. Fitzpatrick
Postmaster: S. Mildred Taylor

The Mayors of Westbury Village

Charles C. Boyd 1932–1935
Robert S. Renison 1935–1936
William H. Greene 1936–1946
Herbert R. Renison 1946–1952
George B. Knipfing 1952–1956
F. Lansing Hunter 1956–1960
John J. Kennelly 1960–1965
Pat J. Buffalino 1965–1975
Dominic J. Piscitelli 1975–1981
Ernest J. Strada 1981–

Pastors of St. Brigid's Church

Fr. McGuiness	1855
Fr. Kelly	1855
Fr. Anthony Farrell	1855
Fr. James McEnroe	1858–1870
Fr. James McCusker	1870

Appendix

Fr. Michael Murray	1892
Fr. Thomas McGronen	1894
Fr. Herbert Farrell	1894
Fr. William McGinnis	1904–1922
Fr. John Moran	1922–1928
Msgr. Daniel Dwyer	1929–1932
Fr. Michael Lopez	1933–1934
Fr. Edward Kehoe	1934–1935
Fr. Loksley Appo	1935–1943
Fr. James Sullivan	1943–1954
Fr. Thomas Code	1954–1975
Fr. Frederick Schaefer	1975–1989
Fr. Francis Gaeta	1989–2001
Fr. Ralph Sommer	2001–

NASSAU COUNTY POPULATION

1900: 55,000
1910: 84,000
1920: 126,000
1930: 303,000
1940: 407,000
1950: 672,000
1959: 1,225,000

NOTABLE WESTBURY NATIVES AND RESIDENTS

Robert Bacon (1860–1919). Secretary of state and ambassador to France, father of Robert Low Bacon. The Children's Library is named after him.

Robert L. Bacon (1884–1938). Colonel, congressman (1923–1938).

Franz Blei (1871–1942) German-born essayist, writer, poet, playwright who emigrated to the United States in the 1930s and died in Westbury.

William Willets Cocks (1861–1932). Politician born in Westbury (see Chapter 1). Buried in the Quaker Cemetery, Westbury.

Esther Hicks Emory (1902–2004). Daughter of Henry Hicks, founding member of the Historical Society of the Westburys, one of the longest lived Westbury residents.

Ethel Rooney Hall (1899–2000). Ethel Hall lived in Westbury for eighty of her one hundred years. She was a star of noted filmmaker Ken Burns's women's rights documentary "Not For Ourselves Alone" in which she told of voting for the first time in 1920.

Elias Hicks (1748–1830). Quaker minister (see Chapter 1).

Frederick Cocks Hicks (1872–1925). Politician born in Westbury (see Chapter 1). Buried in the Quaker Cemetery, Westbury.

Isaac Hicks (1815–1900). Founder of Hicks Nurseries (see Chapter 4).

Rachel Hicks (1789–1878). Quaker preacher (see Chapter 1).

Appendix

Jacques Lebaudy (1868-1919). Born in France, he was heir to a sugar fortune. He became famous when in 1903 he attempted to conquer Northern Africa and labeled himself "Jacques I, Emperor of the Sahara." He wound up living on an estate called The Lodge in Westbury. Eventually, he was shot five times and killed by his wife, French actress Marguerite Doliere. He left an estate worth $4 million.

Nancy McKeon (born 1966). Actress born in Westbury. She is best known for playing "Jo" on the television show *The Facts of Life*.

John S. Phipps (1874–1958). Millionaire who had Westbury House built (the mansion that would later become the centerpiece of Old Westbury Gardens).

Isaac Post (1798–1872). Spiritualist born in Westbury (see Chapter 1).

Herbert S. Pratt (1891–1970s). Born in Westbury, Pratt lived in a Tudor house on Castle Avenue and was known for his numerous paintings of local Westbury and Jericho buildings and scenes of yore.

Bill O'Reilly (born 1949). Born in New York City, he moved to Westbury as a child and attended St. Brigid's School in Westbury. O'Reilly is a conservative television pundit.

Joe Satriani (born 1956). Guitarist was born in Westbury and raised in Carle Place.

Igor Sikorsky (1889–1972). Aircraft innovator who lived in Westbury during the 1920s and opened the Sikorsky airplane factory at Roosevelt Field in Westbury.

Spann Watson (born 1916). One of the original WWII Tuskegee Airmen, he moved to Westbury many years ago.

Gertrude Vanderbilt Whitney (1875-1942). Philanthropist who founded the Whitney Museum of American Art in New York City, lived in Old Westbury.

Notable People Buried at Holy Rood Cemetery in Westbury

Margaret "Unsinkable Molly" Brown (1867–1932). Titanic survivor.

William Casey (1913–1987). CIA director.

Don Dunphy (1908–1998). Boxing announcer.

Maximilian J. Hirsch (1880–1969). Race-horse trainer.

George Morton Levy (1889–1977). Founder of Roosevelt Raceway.

Frank McCormick (1911–1982). Baseball player. Lifetime .299 hitter over thirteen years with the Reds, Phillies and Braves.

Peter Carl "Tex" Millman (1895–1917). Early aviator.

Bibliography

The Answers, by Elias Hicks to the Six Queries Addressed to Him...and with the Doctrines of the Society of Friends. New York: Mahlon Day, 1831.

Boegner, Peggie Phipps, and Richard Gachot. *Halcyon Days.* New York: Harry N. Abrams, 1987.

A Brief Memoir of Solomon Underhill, Late of Westbury, Long Island, including an Address to the Members of the Quarterly Meeting of Westbury. Philadelphia: Joseph R.A. Skerrett, 1827.

Bunker, Mary Powell. *Long Island Genealogies...Being Kindred Descendants of Thomas Powell, of Bethpage, LI, 1688.* Albany: Josel Munsell's Sons, 1895.

Capron, Eliab W., and Henry D. Barron. *Explanation and History of the Mysterious Communion with Spirits, Comprehending the Rise and Progress of the Mysterious Noises in Western New York, Generally Received as Spiritual Communications.* Auburn, NY: Capron and Barron, 1850.

Comly, John, and Isaac Comly, eds. *Friends' Miscellany: Being a Collection of Essays and Fragments, Biographical, Religious, Epistolary, Narrative and Historical.* Philadelphia: J. Richards, 1834.

French, J.H. *Gazetteer of the State of New York.* Syracuse: R. Pearsall Smith, 1860.

Hicks, Rachel. *Memoir of Rachel Hicks, Late of Westbury, Long Island.* New York: G.P. Putnam's Sons, 1880.

Hopper, Isaac T. *Letters of Elias Hicks. Including a Few Short Essays, written on Several Occasions, Mostly Illustrative of his Doctrinal Views.* New York: Isaac T. Hopper, 1834.

Know Long Island: America's Most Complete Community. Hempstead: Community Yearbooks, Inc., 1960.

Lewis, Evan. *Review of the Testimony Issues by the Orthodox Seceders from the Monthly Meetings of Westbury and Jericho against Elias Hicks.* New York: A. Ming, Jr., 1829.

Bibliography

Long Island and Where to Go!! A Descriptive Work Compiled for the Long Island R.R. Co. for the Use and Benefit of its Patrons. New York: Lovibond & Jackson, Publishers, 1877.

Lyman, Susan Elizabeth. *The Story of New York.* New York: Crown Publishers, 1975.

Naylor, Natalie A., ed. *Journeys on Long Island: Travelers' Accounts, Contemporary Descriptions and Residents' Reminiscences, 1744-1893.* Interlaken, NY: Empire State Books, 2002.

New York Times. Various articles.

Old Westbury Gardens: A History and a Guide. Old Westbury: nd.

Palmer, Noel. *Westbury Friends School: The First Forty Years 1957-1997.* New York: 1997.

Prime, Nathaniel S. *Long Island, From its First Settlement by Europeans, to the Year 1845.* New York: Carter, 1845.

Roosevelt, Theodore. *Hunting the Grisly and other Sketches.* New York: G.P. Putnam's Sons, 1893.

Sargent, D.A., et al. *The Out of Door Library: Athletic Sports.* New York: Charles Scribner's Sons, 1897.

Smits, Edward J. *Nassau Suburbia, U.S.A.: The First Seventy-five Years of Nassau County, New York 1899-1974.* New York: Friends of the Nassau County Museum, 1974.

St. Brigid's: Commemorative materials, 1956 and 1981.

Thompson, Benjamin F. *History of Long Island; Containing an Account of the Discovery and Settlement; with Other Important and Interesting Matters to the Present Time.* New York: E. French, 1839.

Vahey, Mary Feeney. A *Hidden History: Slavery, Abolition, and the Underground Railroad in Cow Neck and on Long Island.* Port Washington: Cow Neck Historical Society, 1998.

Weidman, Bette S. and Linda B. Martin. *Nassau County Long Island in Early Photographs 1869-1940.* New York: Dover Publications, 1981.

Westbury Quakers Digital Archives.

Please visit us at
www.historypress.net